"Photography, at its most basic, is a juxtaposition of light and darkness. Capturing an image with the perfect blend of these two things is an art. Rachelle Lee Smith achieves that high standing and raises the bar by bringing not only the light and darkness of the image into focus but also the light and darkness of her subjects. In this profoundly moving and important collection, the art of photography is beautifully pressed beyond its printed product and into the real world where sexuality, love, and identity, and the damage that can be wreaked upon each of them, is exposed."

Gretta Vosper
Minister and author of *With or Without God: Why the Way We Live Is More Important than What We Believe*

"It's often said that our youth are our future. In the LGBT community, before they become the future we must help them survive today. This book showcases the diversity of creative imagination it takes to get us to tomorrow."

Mark Segal
Publisher, *Philadelphia Gay News*
and the nation's most awarded LGBT journalist

speaking OUT

QUEER YOUTH IN FOCUS

Rachelle Lee Smith

Foreword by Candace Gingrich
Afterword by Graeme Taylor

Speaking OUT: Queer Youth in Focus
Rachelle Lee Smith © 2014
This edition © 2014 PM Press

ISBN: 978-1-62963-041-0
LCCN: 2014908062

10 9 8 7 6 5 4 3 2 1

Design by Chris Beck
Cover by John Yates • www.stealworks.com
Additional layout by Jonathan Rowland

PM Press
P.O. Box 23912
Oakland, CA 94623
www.pmpress.org

Reach and Teach
144 West 25th Avenue
San Mateo, CA 94403
www.reachandteach.com

Printed in the USA by the Employee Owners of Thomson-Shore in Dexter, Michigan
www.thomsonshore.com

this book is dedicated to

my family for supporting me as a queer youth...and adult

Megan for supporting me unconditionally

and queer youth everywhere for constant inspiration

FOREWORD

I first had the pleasure to meet Rachelle in 2007 when her "Pride/Prejudice: Voices of GLBT Youth" photograph collection was featured as the first exhibit to be hosted in the Human Rights Campaign's new headquarters. I always enjoy meeting someone who also hails from Pennsylvania, but I don't often meet someone who has the impact that Rachelle and her art are able to offer. The photos were stark, bold, and powerful, and allowed the voices of the subjects to accompany their images. The publication of *Speaking OUT: Queer Youth in Focus* now makes those voices accessible to a wider array of individuals than those lucky enough to attend an exhibit.

"Generation Equality"—the current generation of young Americans—is more supportive of LGBTQ equality and people than any other in the history of the country. It makes sense—to young people today it seems unimaginable that there was ever a time when queer people did not exist. We talk about "digital natives"—those who have grown up with smart phones, social media, and the internet. I think that members of this generation are queer natives. From an early age they have been aware that LGBTQ people exist, either by knowing someone personally or seeing representations of queer people in the media.

But just because there has been visibility doesn't mean that the voices of LGBTQ people are being heard.

But just because there has been visibility doesn't mean that the

8

Candace Gingrich

voices of LGBTQ people are being heard. In fact, as the age of coming out continues to decrease, we still too often see the "children should be seen and not heard" mantra in play. This is why this book is important and necessary. As Rachelle has stated regarding her photos and the book, "I wanted to give people a chance to have a voice, to speak and be heard, even just a little bit."

Rachelle succeeds in giving that voice to many, and the chorus is a powerful one. *Speaking OUT* has the power to educate a wide audience—from individuals who think they don't know anyone queer, to queer people who feel that their own situations are unique. Rachelle says, "When people can relate their stories to someone of a different perspective, that's when change can happen." The book also succeeds in showing the beautiful and amazing diversity of the LGBTQ community, something often missing in the mainstream media.

> *Speaking OUT* has the ability to change perceptions, attitudes, and even the self-esteem of those who read it.

Speaking OUT: Queer Youth in Focus has the ability to change perceptions, attitudes, and even the self-esteem of those who read it. This book should be required reading for teachers, parents, counselors, advisors, and PTA members. I applaud Rachelle for creating such a beautiful and impactful vehicle for change, and know that its impact will be felt through all generations.

THERE IS STRENGTH IN NUMBERS, POWER IN WORDS, AND FREEDOM IN ART.

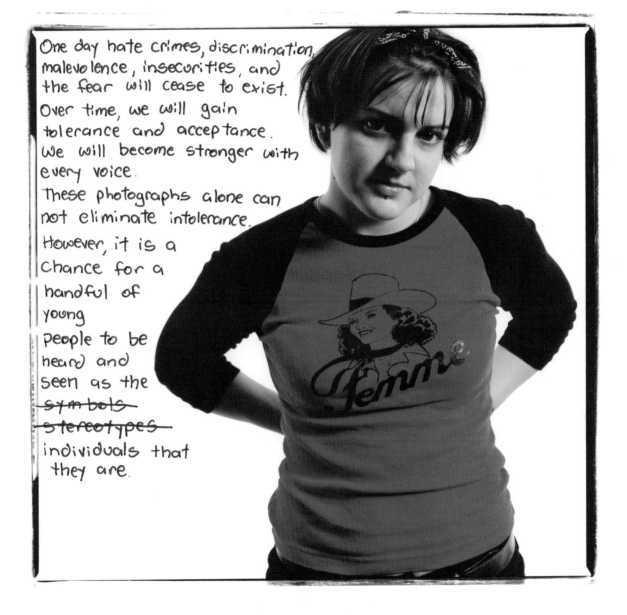

One day hate crimes, discrimination, malevolence, insecurities, and the fear will cease to exist.
Over time, we will gain tolerance and acceptance.
We will become stronger with every voice.
These photographs alone can not eliminate intolerance.
However, it is a chance for a handful of young people to be heard and seen as the ~~symbols~~ ~~stereotypes~~ individuals that they are.

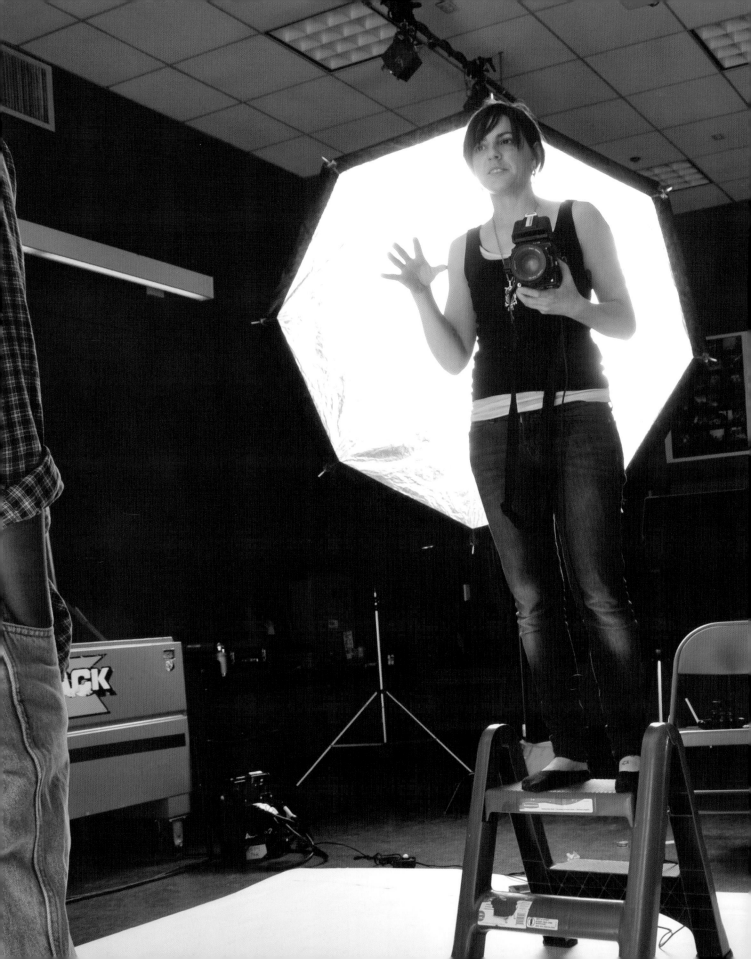

STATEMENT

SPEAKING OUT: Queer Youth in Focus

is a photographic essay that explores a wide spectrum of experiences told from the perspective of a diverse group of young people, ages fourteen to twenty-four, identifying as queer (i.e., lesbian, gay, bisexual, transgender, or questioning). Over a decade, I have worked both as artist and activist to use photographic portraits with the subjects' own words to highlight the myriad differences and commonalities of queer identity.

Portraits are presented without judgment or stereotype by eliminating environmental influence with a stark white backdrop. This backdrop acts as a blank canvas, where each subject's personal thoughts are handwritten onto the final photographic print. What makes this body of work so powerful is not only that each individual is given the spotlight and a chance to have a voice, but also the strength of the group as a whole.

Speaking OUT gives a voice to an underserved group of people that are seldom heard and often silenced. The collaboration of image and accompanying text serves to provide an outlet, show support, open minds, and help those who struggle. It not only shows unification within the LGBTQ community but also the commonalities across all borders regardless of age, race, gender, and sexual orientation.

Now, more than ever, these voices need to be heard.

I believe there is strength in numbers, power in words, and freedom in art, and I strive to raise awareness with this book.

"This collection of youth from all over the world is utterly moving as they show what it's like to come into your own as part of a community that struggles with its own identity and place in society."

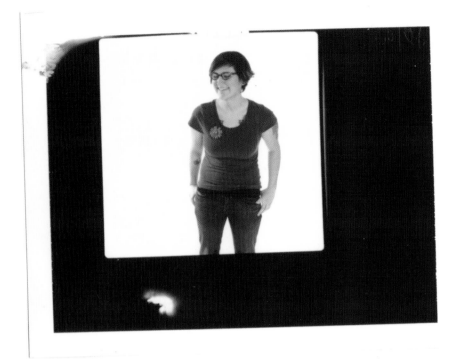

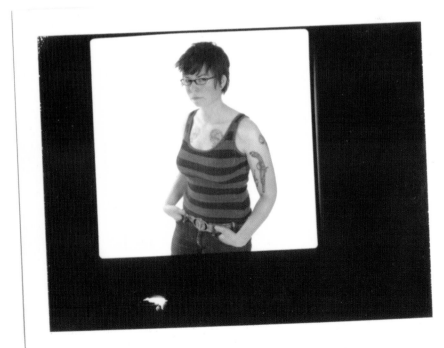

the PROCESS

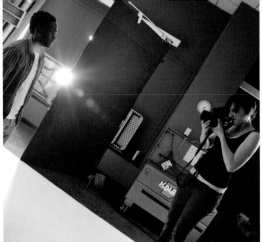

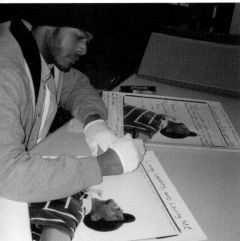
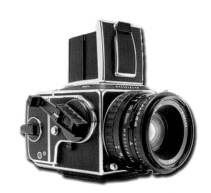
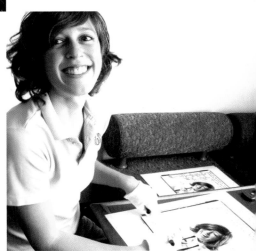

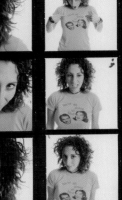
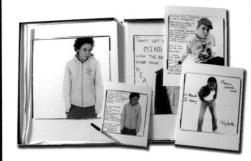
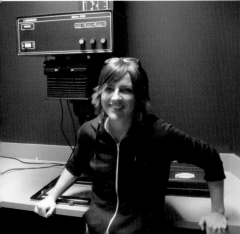

The physical development of *Speaking OUT: Queer Youth in Focus* has been a very rewarding, grassroots, hands-on process. Subjects were introduced to the project by word of mouth, notices at youth centers, and flyers distributed at schools. I started by photographing in my studio in Philadelphia, but as *Speaking OUT* expanded, I was able to photograph people all over the country and began shooting on location with a traveling set-up of cameras, film, lighting gear, and a nine-foot white backdrop.

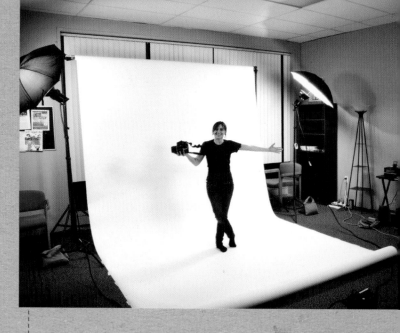

The process goes like this:

First the subjects are photographed. We shoot as much or as little as is needed depending on the comfort level of "acting naturally" amidst a studio setting. I began shooting only with film, but have since incor-porated digital as a backup. The images are made with a Hasselblad 501cm medium format camera.

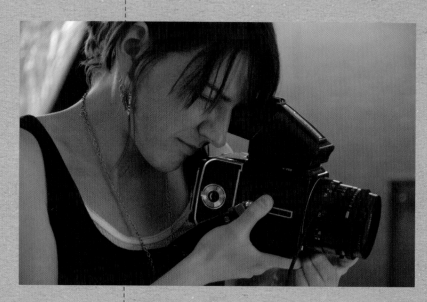

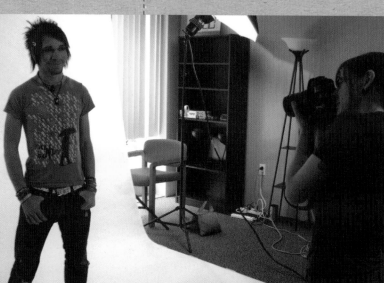

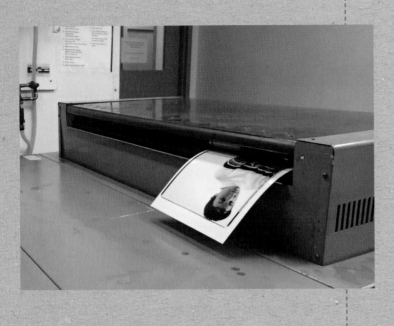

The negatives are 6x6cm square, and there are twelve frames per roll of film. The black square around each image is the border of the negative.

After the film is developed, I print a contact sheet in a darkroom with one of the last remaining Colex color processors in the U.S.

Once the contact sheets are printed, I meet with the subject and together we decide on the photograph that is to be the "one." Sometimes people have an idea of what they are trying to convey and they choose a photograph to portray this idea. I encourage choosing a portrait that really gets to the heart of their feelings and the reason they chose to be involved in this project.

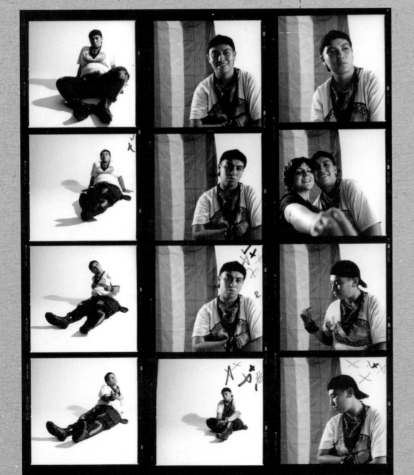

I also weigh in on the technical side. Because I print the images full frame with no cropping (hence the border), I pay close attention to everything happening around the subject. I look for focus, stray cables, the clarity of the backdrop, hot spots, and other irregularities.

After a photo is chosen, I head back into the darkroom and make a series of prints. I print a small one (8x10") that is ideal for portability and for scanning into digital formats. I also make several large 16x20" images for gallery showings. I meet again with the subject, and they write their story directly onto the photograph. Some people prepare months in advance, others ad-lib their writing the day of. I never know how the finished image will look. Each one is a unique, handmade, one-of-a-kind piece.

This project began as an exploration of activism, storytelling, and growth. The very first person to be photographed for *Speaking OUT* was living on the street while passing through Philadelphia. I

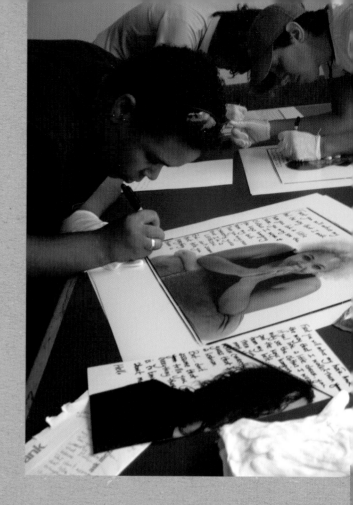

followed Joey to where she panhandled, where she spent her days, and where she slept. A few days had passed, and she was about to hop a train headed to the West Coast. Before she left, I brought her into the studio for some test shots.

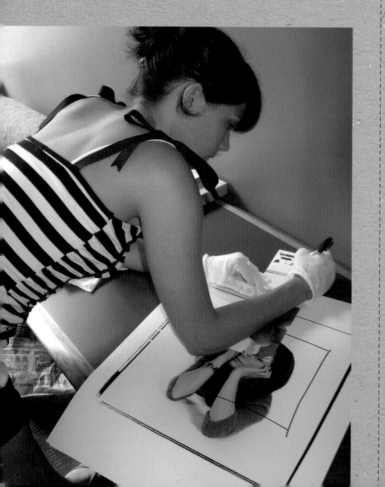

During the photo session I had the rare privilege, as an outsider, to be invited to train hop with her. This would have taken the project to a different place entirely and would have left me with some amazing stories. But I declined and chose to leave the storytelling up to her. That decision continues to inform this body of work.

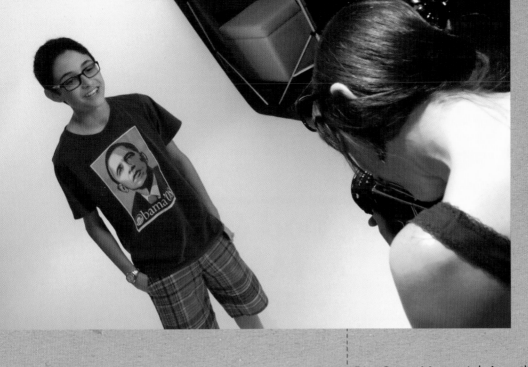

The last person I photographed was Graeme Taylor, who I was honored to have write the afterword for this book. I photographed Graeme when he was awarded the SuAnne Big Crow Memorial Award at the National Education Association's annual Human and Civil Rights Awards Dinner. The contrast and metaphor of growth over time is one that I feel compelled to share.

From a panhandler to a civil rights awardee, photographing and following up with the people in this book has led to many experiences and stories outside of what is printed here. While the work continues to help and inspire others, it has also helped me grow as a photographer and a person. I have made lifelong friends, met inspiring individuals, and learned so much along the way.

My hope is that this book and these images will continue to create awareness and dialogue not only about what sets us apart but how we all relate and, ultimately, what makes each of us extraordinary.

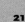

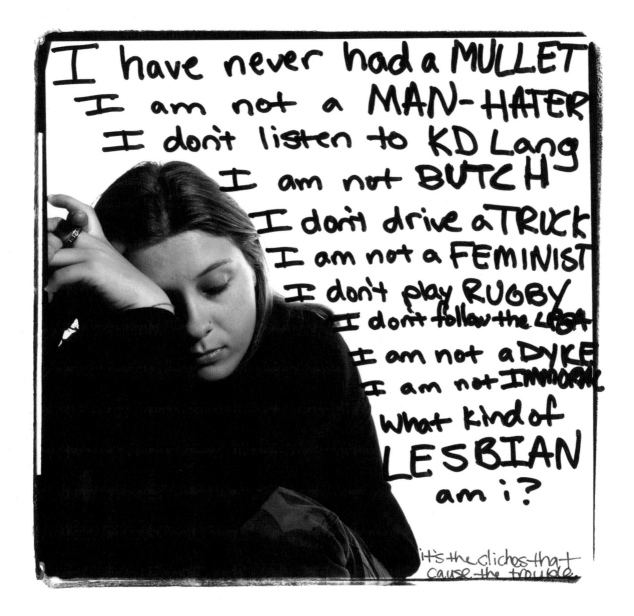

I have never had a MULLET
I am not a MAN-HATER
I don't listen to KD Lang
I am not BUTCH
I don't drive a TRUCK
I am not a FEMINIST
I don't play RUGBY
I don't follow the LPGA
I am not a DYKE
I am not IMMORAL
What kind of LESBIAN am i?

it's the cliches that cause the trouble.

I am a Mixed Race Queer Trans MAN
With the innate ability to proud Service

Athletic,
Charming,
Nerdy,
Well dressed
and
VERSATILE

The Dandy Club

I have a thing for Star Wars, a Thick Steak, LEATHER, and being Slicked up AND I AM Francesco

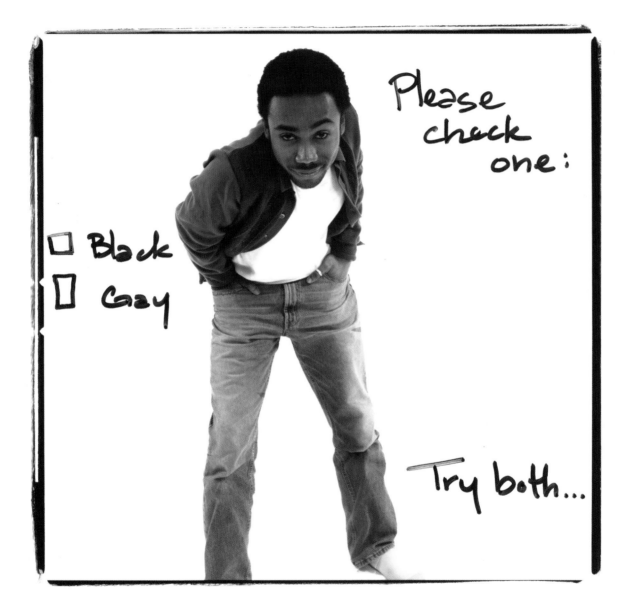

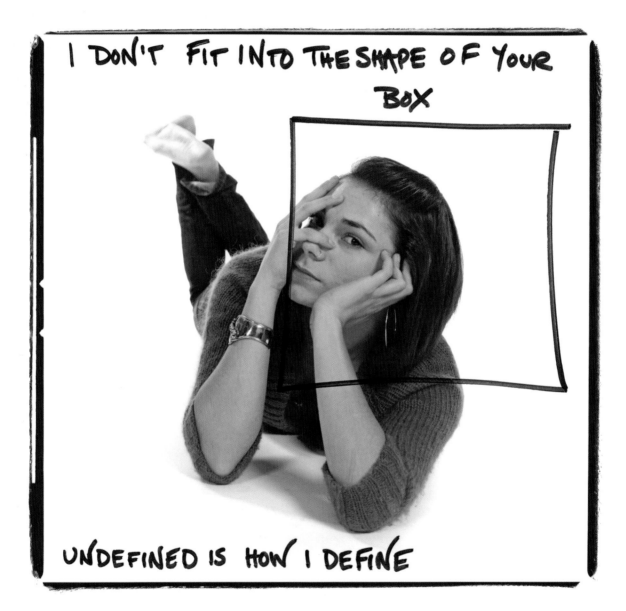

I DON'T FIT INTO THE SHAPE OF YOUR BOX

UNDEFINED IS HOW I DEFINE

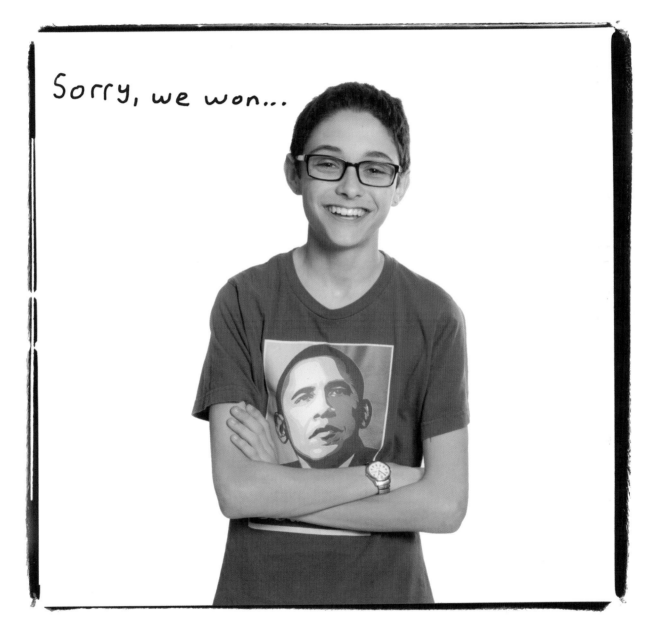

Sorry, we won...

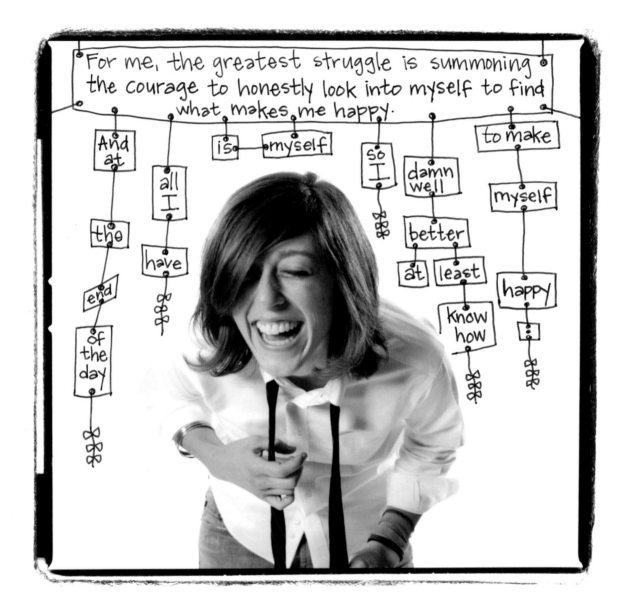

MEGAN

I was really unhappy during my college years. I had no idea why. High school was fine, but in college I started feeling like I didn't know who I was and felt unhappy living in my own skin. It was miserable. I tried therapy and anti-depressants. Those helped a little bit, but nothing really took that feeling away. Finally, during my last semester of college, I decided to open myself to living without all of the rules and restrictions I had been imposing upon myself. Rules about being a good student, a good friend, a good daughter. Restrictions on how I ate, what I wore, how I spent my time. It didn't take long before the inspiration came to me that I am gay. Once I had the realization and began being honest about it, things started to return to normal and I began to feel like my old happy self again. It took some time and it wasn't overnight, but I discovered I was actually a better friend and daughter when I liked myself. So, my portrait is about that process of discovering how to be honest and accepting of yourself. You might be surprised by what you find when you are truly honest with yourself, but you only have one life and it's yours to live. No one can make you happy if you can't be happy with yourself. I think being honest and kind to others starts with being honest and kind to yourself.

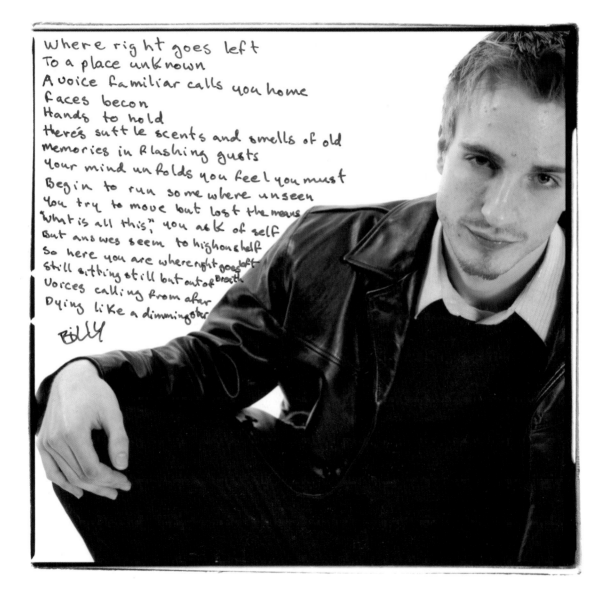

where right goes left
To a place unknown
A voice familiar calls you home
Faces becon
Hands to hold
There's suttle scents and smells of old
Memories in flashing gusts
Your mind unfolds you feel you must
Begin to run some where unseen
You try to move but lost the means
"What is all this", you ask of self
But answes seem to high on shelf
So here you are where right goes left
Still sitting still but out of breath
Voices calling from afar
Dying like a dimming star

Billy

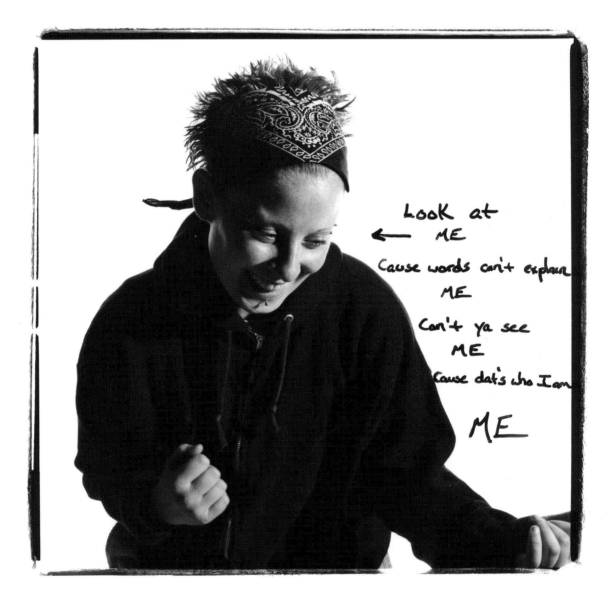

Look at
 ME
Cause words can't explain
 ME
Can't ya see
 ME
Cause dat's who I am

 ME

"It's wonderful to see so many happy kids. You wouldn't have seen such a crowd fifty years ago. Sometimes things do get better."

Ed Hermance
Owner, Giovanni's Room,
the oldest LGBT bookstore in America

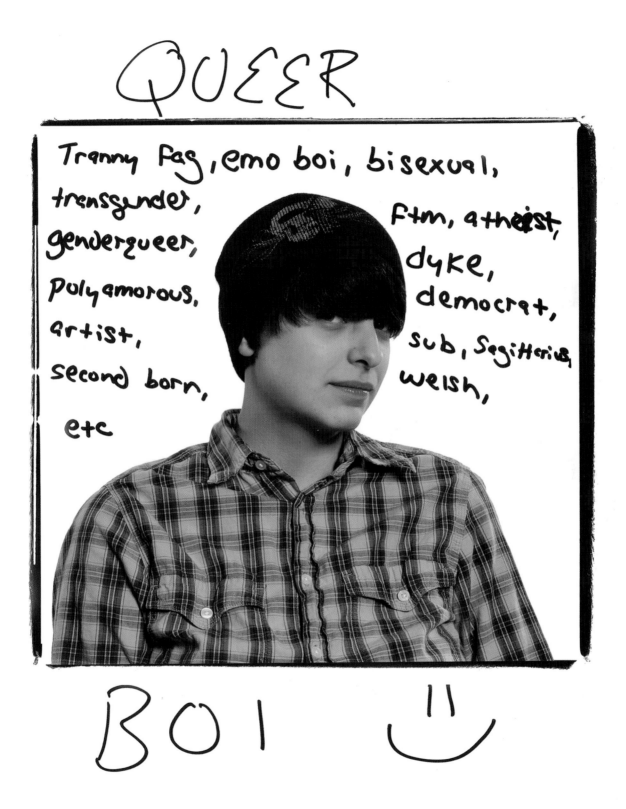

QUEER

Tranny Fag, emo boi, bisexual, transgender, ftm, atheist, genderqueer, dyke, democrat, polyamorous, sub, Sagittarius, artist, welsh, second born, etc

BOI :)

In high school I dated boys—
I was a straight girl.

After starting college, I
identified as a card-
carrying dyke.

Soon I realized that what I
was feeling wasn't about
sexual orientation, it
was about gender:
I came out as a
guy the summer of '99.

Now I live
my life as a
gay man—

a punk
rock queer
boy
who

happens to also be in
love with a girl.

Who knows? Maybe next year I'll grow a tail.

SAY WHAT? OH NO.

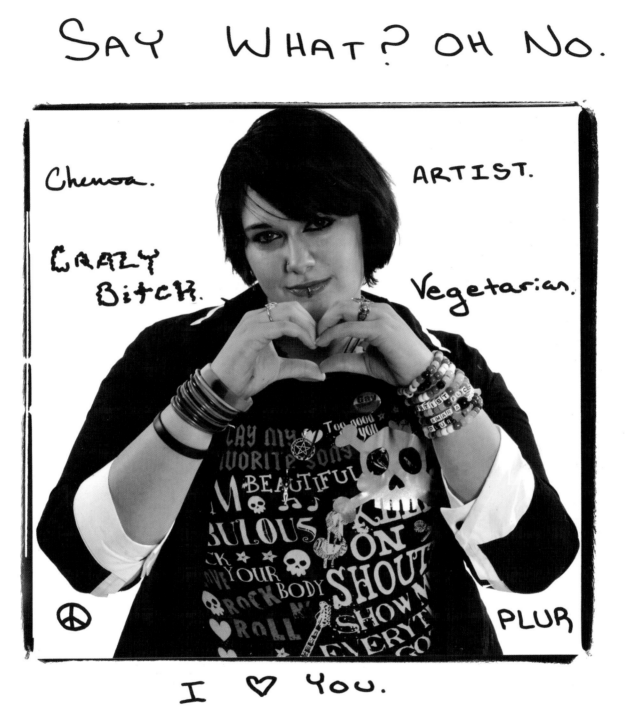

Chenoa.

ARTIST.

CRAZY Bitch.

Vegetarian.

PLUR

I ♡ You.

Professional Hag.

OMG Ferealz.

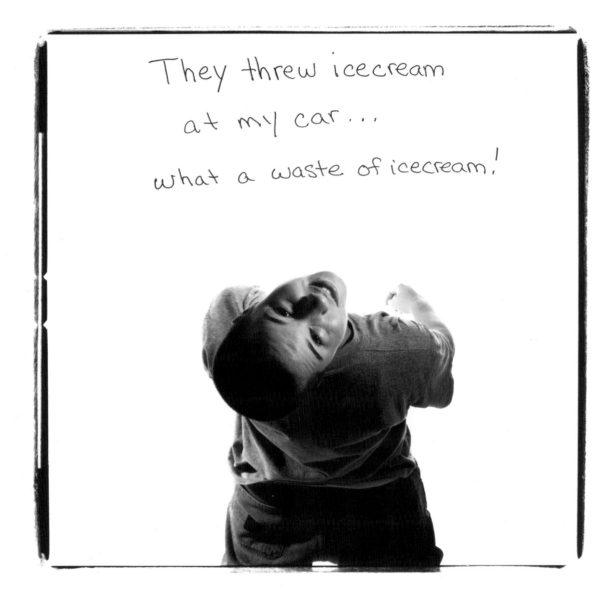

They threw icecream
at my car...
what a waste of icecream!

BETH ➡ MATTY

When I look back at that point now, I have two thoughts: 1) I'm not sure I can bend backwards quite so easily anymore and 2) What a random day that was when those girls called me a dyke and threw ice cream at my car. Sadly, that hasn't been the only time I have ever experienced a homophobic, transphobic rant or slur sent my way, but it has changed how I view those experiences. I try to keep a sense of humor and an even stronger sense of myself. After all, someone else's words do not and will not change who I am. They're just words. One thing I might like to add to that print today would be, "My favorite flavor is Ben & Jerry's Vanilla Caramel Fudge ice cream . . . Now accepting donations!"

SPEAKING OUT REMINDS
US OF SOMETHING ABOUT
YOUNG PEOPLE THAT IS
OFTEN FORGOTTEN:

WHATEVER THEIR SEXUAL ORIENTATION,

GENDER IDENTITY, RACE, ETHNICITY,

OR CULTURE, THEY ARE BEAUTIFUL AND

IMPORTANT, UNIQUE AND VALUABLE."

ERIN GOTTHARDT
Coordinator
Identity Center, New York

The first girl I's
ever kissed made
me feel like
that →

:)

Such a geek!!

ALYSSA

We work all our lives to survive . . . but then what? There are an abysmal amount of seemingly meaningless interactions we partake in, in order to be successful, do well, and get by. In fact, everything we do somehow contributes to this need to exist. However, of all the things we do, love seems to overcome all obstacles. In its honest kindness, selflessness, and power, it propels us to not only exist, but to live. I've spent the majority of my life deeply in love with as many aspects of my life as possible. My friends, my work, my family, and all other facets of my boring everyday existence fill me with so much joy. Even when I want to harm them, I know that the immeasurable love I have for them far surpasses any negativity. I've also spent the majority of my life listening to people tell me that the only valid romantic love is the love between a man and a woman. Arguing their points so much as to negate the love portion and jump straight to a platonic relationship, which, based on their argument, leaves marriage nothing more than a distorted economical loophole, and procreation tool. If that is the heterosexist view of love, then the only ones who can save it are, in fact, those who love differently. My love is all-encompassing and is nonjudgmental. It is kind, selfless, and powerful. And! I surely have enough to give a little to everyone, so what should it matter if I want to give all the romantic kind to another woman?

my name is bucky and this one time,
in the middle of my first year of college,
driving down route 13 i told my
friend giovanna i was
bisexual. the look of
shock and disgust was
the epitomy of her
sheltered, religious
upbringing. needless
to say, she now
seriously doubted
our friendship and
asked to exit the
moving car. i told
her, "not until you
allow me to explain"
eventually she stopped
pretending i never told
her and became enlightened

I pace in a land
congested by dreams
where a small grain of sand
is not how it seems
I've heard hollow-faint voices
whisper my name
Yet, those so silent voices
don't awe sound the same
And some I recall just say it with shame.

So, I sculpt white-cotton
castles from the clouds
that roll by —
I take of the ground
what I can of the sky
I paint every ray
that shines from the sun
I live every day to be better than one
I dream of graces & splendor of
royal deploy
I look for
traces of
grandour
alloted with joy
And I think and think of what all of this is about —
Me. locked in a place that I need to be OUT.

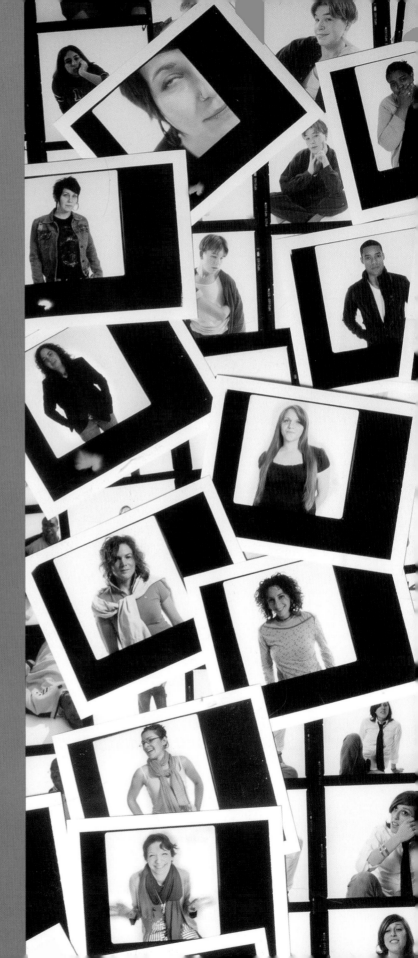

"An incredible book
that serves as the
culmination of a
ten-year effort
to document the
lives and tell
the stories of
queer youth."

Huffington Post

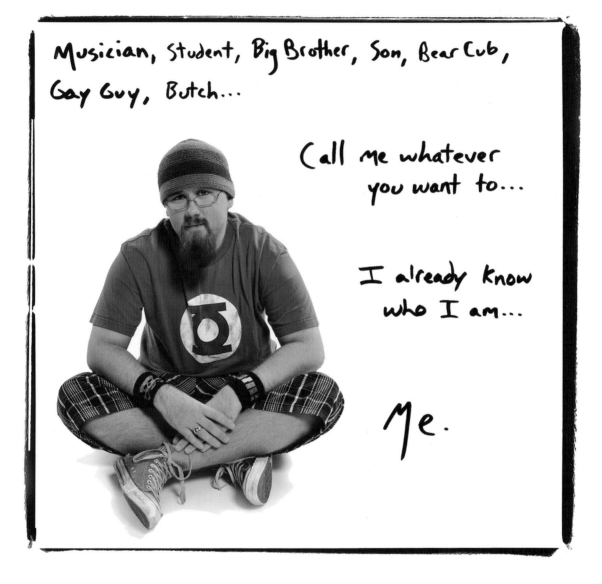

Musician, Student, Big Brother, Son, Bear Cub, Gay Guy, Butch...

Call me whatever you want to...

I already know who I am...

Me.

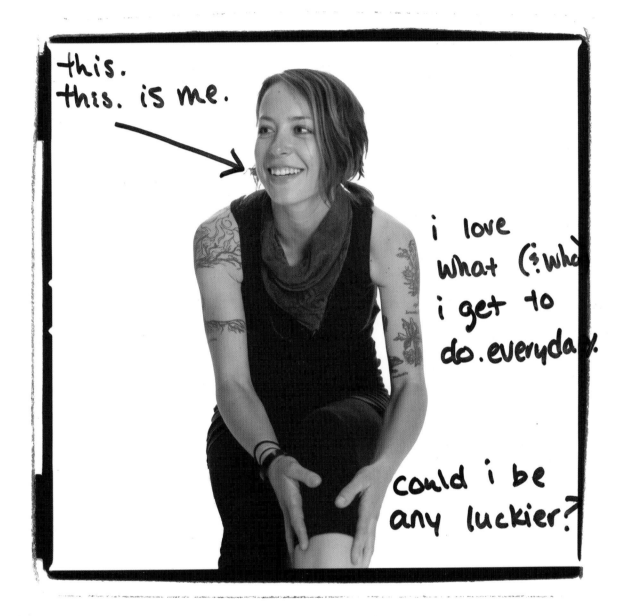

Straight? No...
Gay? no...
Those words
don't feel
Right.
They aren't Me

Bi? Closer,
but still
not Right.
Queer...
...YES
 I'm Queer,
 That's Me!

Its Tuesday Ni[ght]
and I'm at a frie[nd's]
pokin the smot wi[th]
some people in a
basement when
some strg assholes
from grade school
show up and start
harrassing me while
I'm high so it's hittin[g]
me like 10 and ma[kes]
me feel like I'm in grade
School all over [again] so I
leave a gonna [want] to cry.
When an all [_____] voice is on m[y _____] machine
This strg gu[y _____] school my best [_____] [____]d I
fooled arou[nd _____] a year ago w[_____ _____]ird who
considered m[y _____]end a[____] tell[_____ _____]ws off
and jerked us around [____]en it [_____ _____] that he might be
gay. Anyway me wants to s[_____]over m[y] house because
he was "locked out". He c[____]es in DRUNK "Falls asleep"
next to me, we fool arou[nd ___] a few hours he leaves
confused yet again in the [____]ning and I sit in my
bed wondering who do[__ ___ __]ppen to on a Tuesday
Night.

I don't walk with a limp wrist & my hands flared out.

I'm not always over-dramatic.

I'm not a stuck up "girl wanna be."

I don't go after every guy I see.

I'm like a transformer there is deff. more that meets the eye.

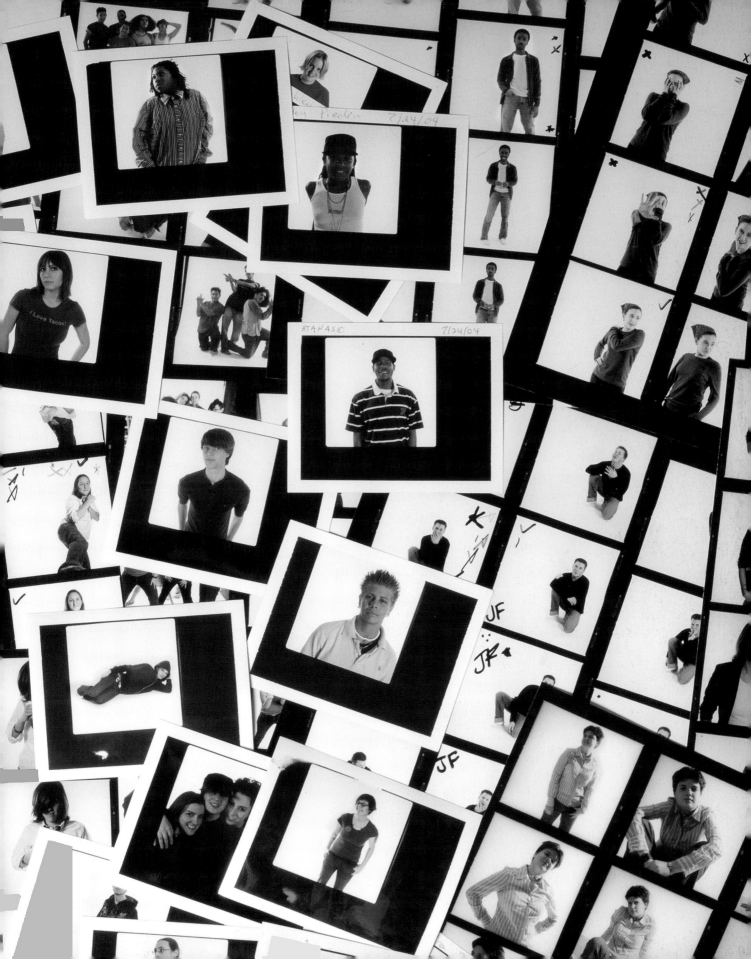

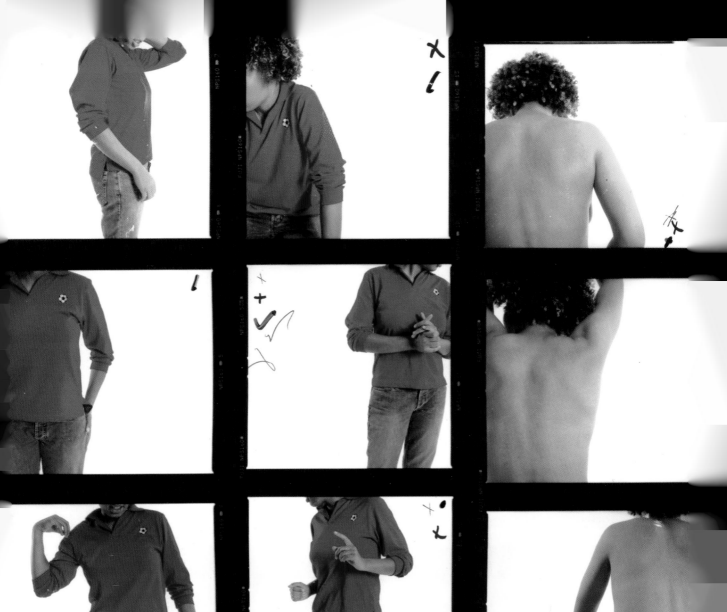

ONE CAN TAKE WHAT I SAY AS A WHOLE, OR THEY CAN QUOTE PARTS OF IT. AFTER ALL, THAT IS LIFE. PEOPLE HEAR WHAT THEY WANT TO HEAR, AND SEE WHAT THEY

WANT TO SEE. I AM DOING THE SAME THING, I AM LETTING YOU SEE PART OF ME. PART OF WHAT I HAVE TO OFFER. THAT IS THE PHENOMONAL QUALITY OF HUMAN PHILOSOPHY. NO ONE BUT YOURSELF IS ABLE TO **TRULY** INTERPRET WHAT YOU THINK & FEEL, THEY CAN ONLY INFER FROM WHAT THEY **SEE**.

EDITH

Well, Well. What strange only have to justify my actions to myself. And right now I'm waiting to steal my fifteen minutes. Life is what you make it. Don't choose to create your own personal hell.

I want to be now t nostalgic.

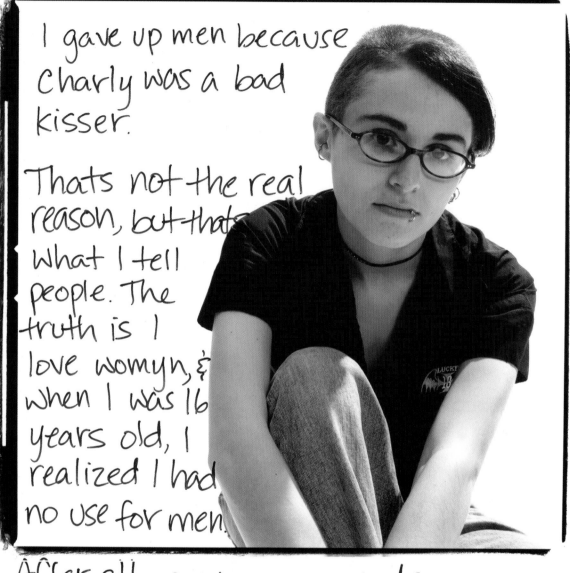

I gave up men because Charly was a bad kisser.

Thats not the real reason, but thats what I tell people. The truth is I love womyn, & when I was 16 years old, I realized I had no use for men.

After all, a woman needs a man like a fish needs a bicycle

HILERI

SINCE THE PHOTO WAS TAKEN I HAVE RECEIVED MY BFA FROM UNIVERSITY OF THE ARTS. I HAVE SINCE MET MY FIANCÉE, AND WE ARE PLANNING OUR WEDDING. WHEN I LOOK AT THE PRINT NOW . . . I SEE MY YOUTH AND IMMATURITY. PERHAPS NOW I WOULD WRITE SOMETHING MORE SERIOUS AND INTROSPECTIVE. ALTHOUGH MY MESSAGE WAS TRUTHFUL, IT SOUNDS SO CHEESY TO ME NOW.

When I think of the person I am today and what I've been thru to get here, one phrase comes to mind that I'm sure you've all heard — SELF LOVE is the only LOVE. I cannot recall how many times Ive been called a fag or a sissy, but I do know that none of that matters at all anymore

because

I am more comfortable in my own skin now than Ive ever been. My wish is the boy I used to be could see how much he is loved today and how proud I am of him for sticking it through — I LOVE YOU!

"If you want it, come and get it, for cryin' out loud. The love that I was givin' you was never in doubt Let go of your heart let go of your head and FEEL IT NOW"
— DAVID GRAY

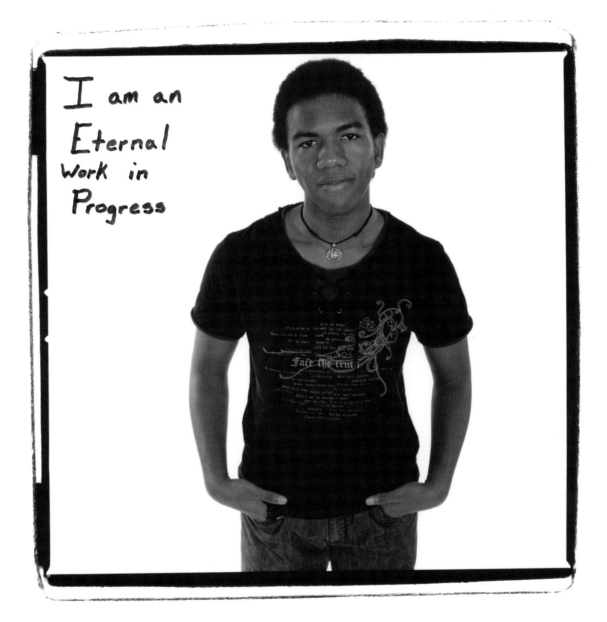

I am an Eternal Work in Progress

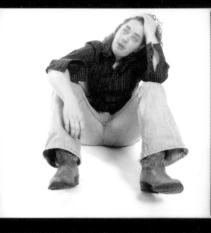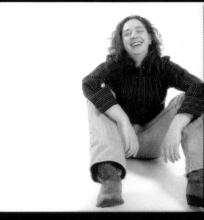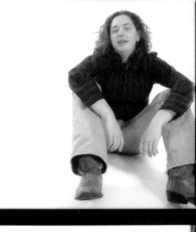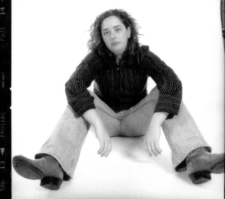

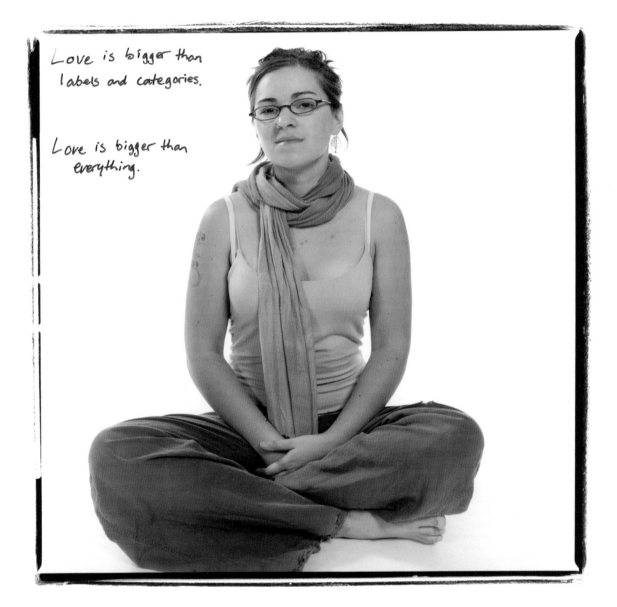

Love is bigger than labels and categories.

Love is bigger than everything.

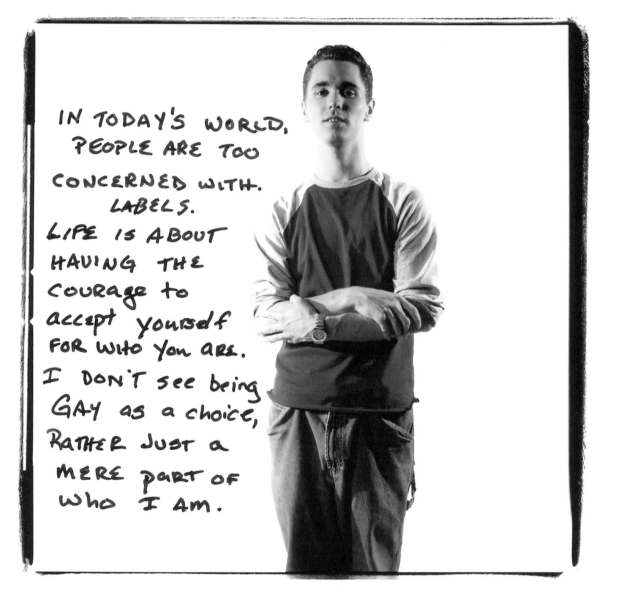

IN TODAY'S WORLD,
PEOPLE ARE TOO
CONCERNED WITH.
LABELS.
LIFE IS ABOUT
HAVING THE
COURAGE TO
accept yourself
FOR WHO YOU ARE.
I DON'T see being
GAY as a choice,
RATHER JUST a
MERE part of
WHO I AM.

Ashley 7/24

MY FIRST STRAIGHT EXPERIENCE.......

I WENT TO HIGHSCHOOL IN Bumblefuck). AND FOR THE MOST THROW PARTIES...WHERE OF AND WE WOULD DO ONE PARTICULAR PARTY INCLUDED). NINE THINK IT WOULD HAVE BUT EVERYONE WAS "STRAIGHT" GUYS ("STRAIGHT"), BRAIN, AND I THING YOU KNOW HE POURED THIS WENT ON FOR A LITTLE TAKE A SHOWER. THE SHOWER THE HOUSE. SO I LEFT TO GO AND I START UNDRESSING, THE A MINUTE PASSED WHEN IT WAS ONE OF MY THIS HOT FUCKING MOUTH TONGUE PLAYING WITH MY AND HE JUST WANTED ON FOR (IT FELT LIKE HOURS) PRESSURE ON MY BALLS THEN I JUST THE LIKE HE WANTED TO SUCK SHRIVLED UP AND WENT DRY BLOW JOB.... YOU

THE MIDDLE OF NOWHERE (right next to PART. TO ENTERTAIN OUR SELVES WE WOULD COURSE, EVERYONE WOULD GET FUCKING BLITZ CRAZY SHIT... WELL... BECAUSE IT WAS FUN. THERE WAS ABOUT 10 PEOPLE THERE (MYSELF GUYS AND ONE GIRL. YOU'D BEEN JUST ONE BIG FUCKING ORGY.

(MYSELF EXCLUDED). ANYWAY ONE OF THE WERE SITTING ON THE COUCH, NEXT BEER ON ME. SO I SPIT BEER ON HIM. WHILE, UNTIL I SAID I WAS GOING TO WAS IN A DIFFERENT PART OF CLEAN UP. I GET TO THE SHOWER THE WATER ON AND GET IN. NOT EVEN THE LIGHTS WENT OFF. I FIGURED

FRIENDS FUCKING AROUND. UNTIL I FEEL AROUND MY COCK, AND THEN A WARM, MOIST BALLS LIKE THEY WERE EVERLASTING GOBSTOPERS TO GET TO THE CENTER. THIS WENT PROBALLY 30 MINS. I COULD FEEL THE FROM HOLDING BACK MY LOAD. FUCK GO, AND HE GUZZLED IT MY JUICES OUT OF ME UNTIL I DAMN THAT WAS A GOOD JUST HAVE TO LOVE

"THE STRAIGHT BOYS"

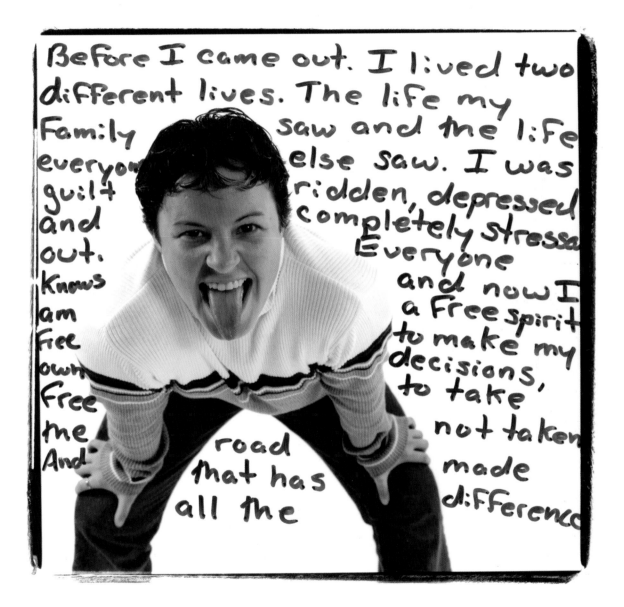

Before I came out. I lived two different lives. The life my Family everyone saw and the life guilt everyone else saw. I was and ridden, depressed out. completely stressed Knows Everyone am and now I Free a Free spirit own to make my Free decisions, the to take And not taken road made that has difference all the

Gosh, it feels like I've been out forever now... over 9 years. (wow! That's a long time.)

I've met some interesting people from every walk of life. It taught me to be open minded to people who are "different."

These "different" people (as deemed by our culture) might be attracted to the same sex or men wearing women's clothing or just about anything the mind can think of.

Growing up gay allows you to keep an open mind to various cultures and beliefs.

My story isn't to focus on the negative but the positive. I've met really great people who are like me... Gay! I've experienced falling in love, a few broken hearts and lot and lots of laughter.

But mostly, I've learned to live each day to the fullest and surround myself with great friends!

I'm proud of who I am.

I'm happy.
I'm gay!

— Jeffrey Cui

JEFF

I took a moment to read what I wrote 10 years ago. I said that I was out for 9 years back then. Gosh, do I feel old and look a heck of a lot different—better, of course! I've been gay and out for 19 years of my 33 on this planet. In those 19 years, I've experienced so many great times and not-so-great times; but life is short and we need to make the best of the worst times and cherish the good times and our family and friends. The last few years of my professional life, I've been very lucky to experience so many unique cultures around the world. I've learned that everyone has great stories to share and all people, no matter who they are, have a natural need to connect with others—gay or straight, black or white, tall or short. No matter who you are, don't let stereotypes define you, but let your heart, soul, and personality shine through!

Soo before I begin PLEASE let me make you understand... I AM GAY... now w/ that said, I have a confession! I'm curious about GIRLS!! For example, one of the privelages about being gay is that girls change in front of u all

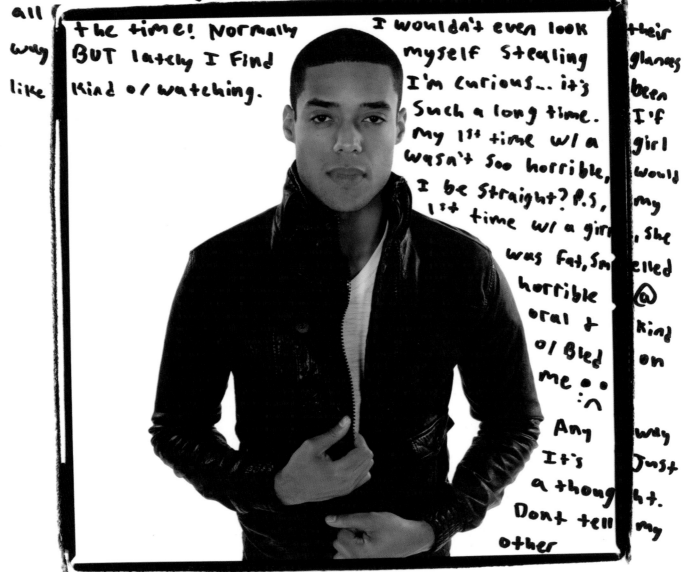

the time! Normally BUT lately I find kind of watching. I wouldn't even look myself stealing I'm curious... it's such a long time. If my 1st time w/ a wasn't soo horrible, I be straight? P.S, 1st time w/ a gir was fat, sm horrible oral + of Bled me oo :^ Any It's a thoug Don't tell other way like their glances been I 'f girl would my , she elled @ kind on way Just ht. my

girlfriends... they won't change infront of me anymore. Beside remember, I like dick (actually not really, I have horrible gay reflexes) I'm more of an ASS man.
 xoxo Josh

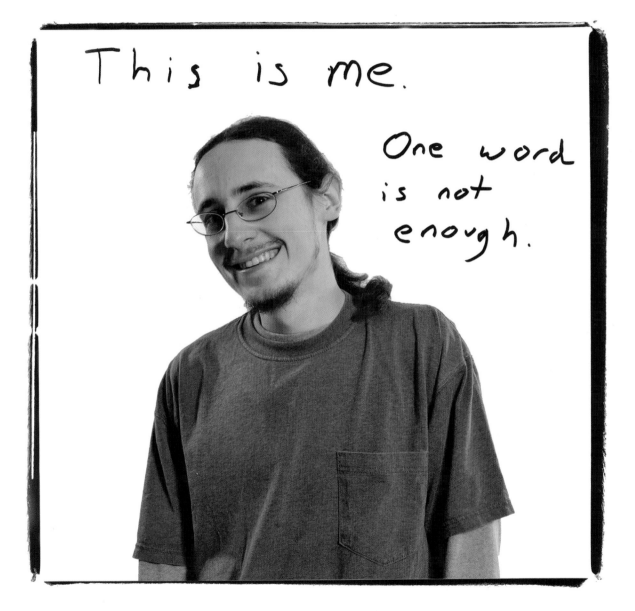

This is me.

One word is not enough.

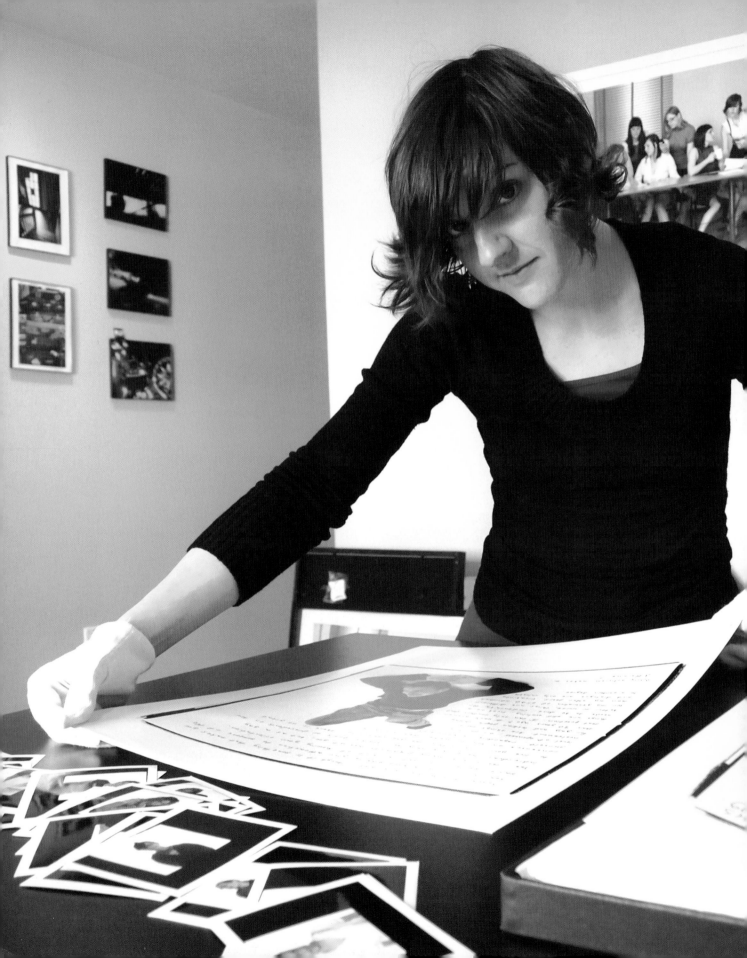

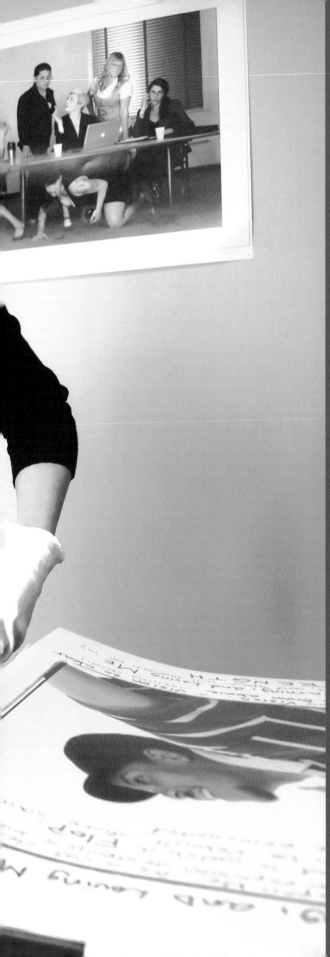

"RACHELLE LEE SMITH HAS CREATED A POWERFUL [BOOK] SHARING THE STORIES OF LESBIAN, GAY, BISEXUAL, AND TRANSGENDER YOUTH. YOUTH FROM ACROSS THE COUNTRY WERE PHOTOGRAPHED AND ASKED TO OFFER THEIR **VOICE**, OPINIONS, AND COMMENTS ABOUT THEIR EXPERIENCE AS LGBT. IN THEIR OWN WORDS AND HANDWRITING, THESE YOUTH HAVE SHARED THEIR STORIES CREATING A VERY INTIMATE AND PERSONAL VIEW ON WHAT IT IS LIKE TO BE A LGBT PERSON TODAY."

HUMAN RIGHTS CAMPAIGN

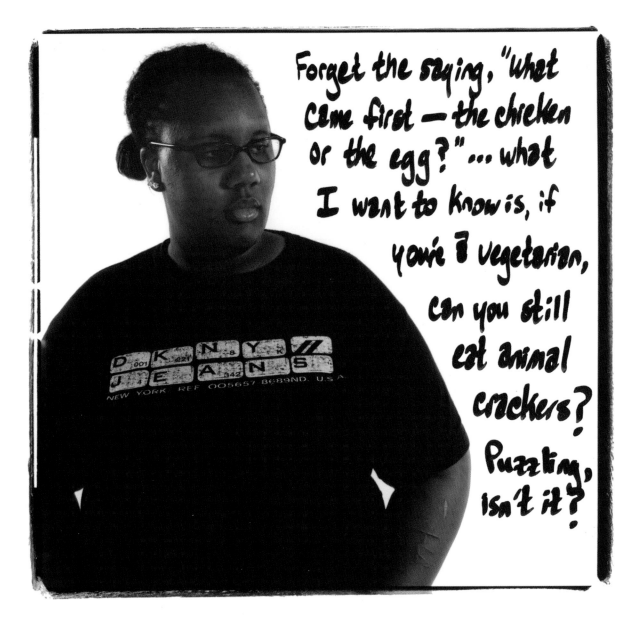

I'm a 19 year-old train-hopping squatter gutter punk from California, traveling since the age of 13. I do have to say it has been hard—especially being a lesbian. Either people in my scene give me shit or my girlfriend does— its always your life is too much or you drink too much or my favorite - you "crave stability."

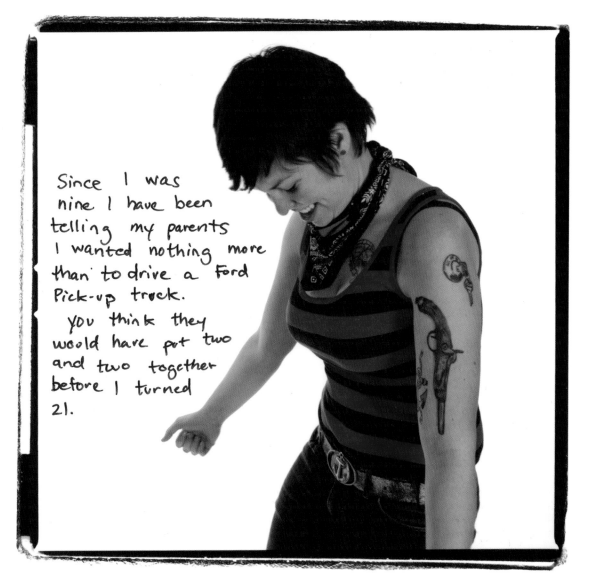

Since I was nine I have been telling my parents I wanted nothing more than to drive a Ford Pick-up truck.
You think they would have put two and two together before I turned 21.

KRISTIN

I'm not sure what I would write on my photo now but it would certainly not be something as snarky as what I wrote at the tender age of 22. When I look at what I wrote, it makes me laugh because what I wrote isn't deep and somewhat pokes fun at lesbians (or me) for being "butch," which isn't something I agree with at all—or did at the time. So many years have passed since that photo was taken of me, and I've grown a lot but I'm still the same person I was, just a little more street-smart I'd say. I still want a pickup truck but I'm making it by with my vintage car and various two-wheeled vehicles, and you know what? I still don't give a shit about what people think about me or my choices and that's all that matters to me for now.

DON'T JUDGE ME

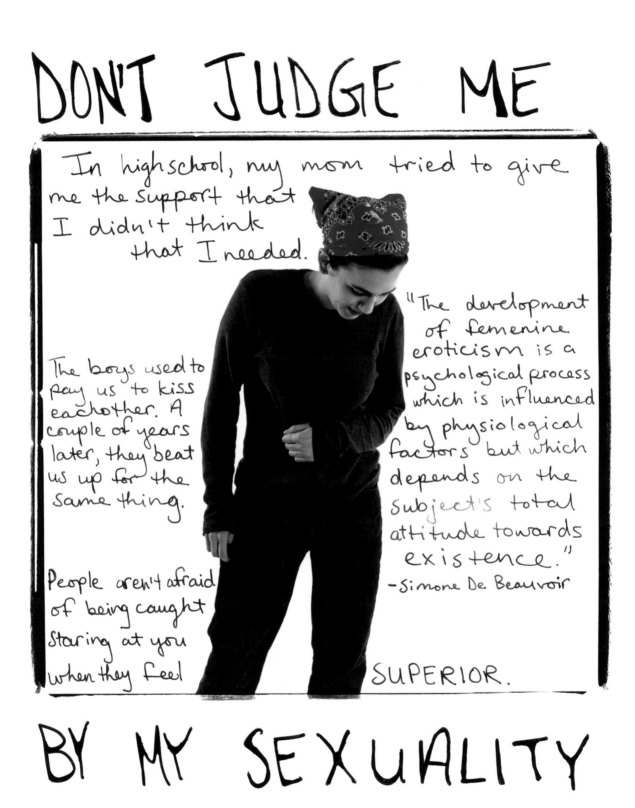

In highschool, my mom tried to give me the support that I didn't think that I needed.

The boys used to pay us to kiss eachother. A couple of years later, they beat us up for the same thing.

People aren't afraid of being caught staring at you when they feel

"The development of femenine eroticism is a psychological process which is influenced by physiological factors but which depends on the subject's total attitude towards existence."
—Simone De Beauvoir

SUPERIOR.

BY MY SEXUALITY

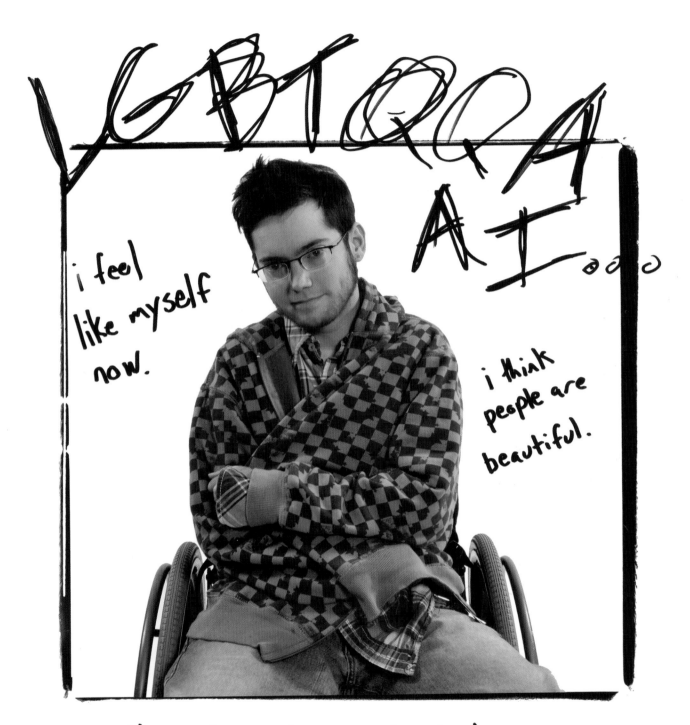

LGBTQQA AI...

i feel like myself now.

i think people are beautiful.

it's not that complicated.

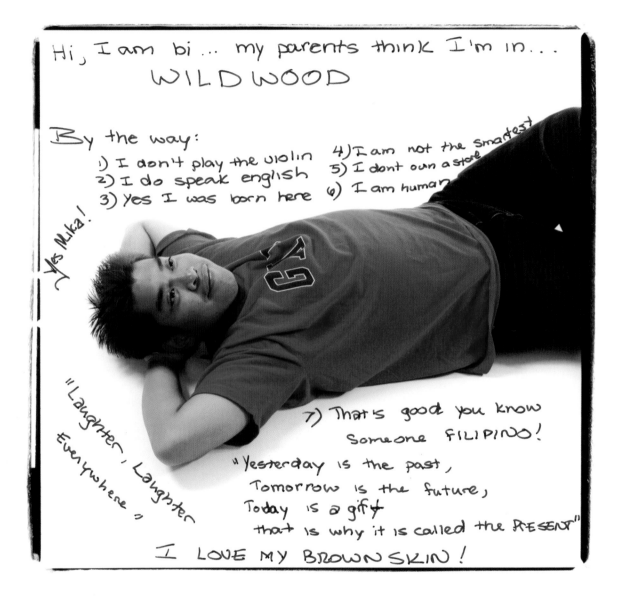

CHRIS

I am pretty sure when I took that picture I was 17. I am 27 now and my life definitely has changed from that very outspoken little boy to a very opinionated man. When I wrote on that picture I remember feeling so alive and liberated because I was able to identify all the boxes I could categorize myself at that time. I think as I have gotten older it became even more liberating to break out of those boxes because I was able to be me, without adhering to a specific box. I have learned that self-definition is more important than a societal identity. I have spent a lot of my life educating myself on the different components that make me, me. I have lived, by choice, up and down the East Coast and currently in California. Over time I have found myself both in the spotlight and behind the scenes in LGBTQ agendas. I was a co-founder of the first gay fraternity at an Ivy League university, Penn, that emphasized the importance of self-empowerment and unity outside the traditional gay social realms. We also focused on community service and refocusing the stigmas and social generalizations that are sometimes synonymous with gay men. Outside of college life, I have worked very hard towards my own milestones and goals. With a future set in the fashion world, I have decided to attain my degree in fashion design. I currently own my own business as a personal fashion consultant, and business is good. I have worked with various clients and designers in doing fashion shows and TV segments. The one thing that hasn't changed since that picture was taken was my drive for big things and big success. If I were to write on a picture today it would say, "Define yourself by learning who you are, not by learning what others think about you." "Being challenged is better than settling." "You only get one first impression so make an impact." "Make a list of all the things you don't like about yourself, then throw it out." "If you can't laugh at yourself, you'll soon find out that you're really the joke." And lastly, "There is no greater success than waking up, looking in the mirror, and saying, 'Damn you are gorgeous, flaws and all!'"

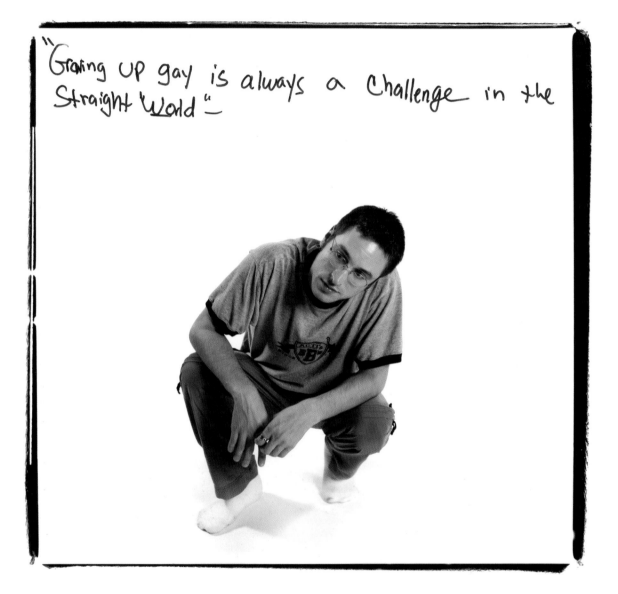

"Growing up gay is always a challenge in the Straight 'World'"

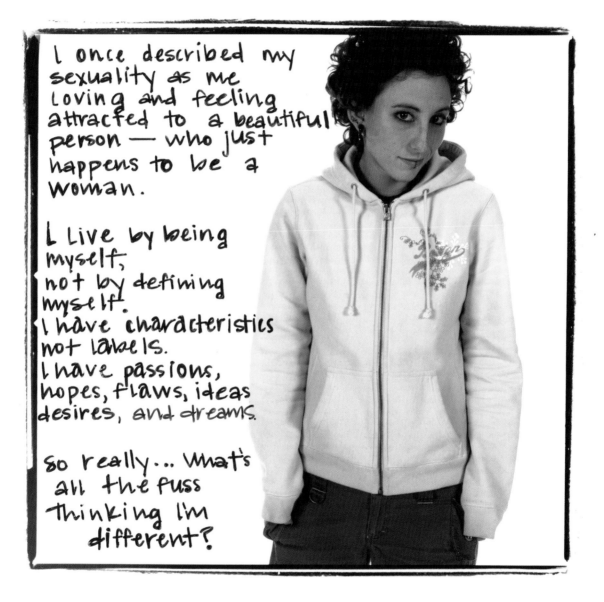

I once described my
sexuality as me
loving and feeling
attracted to a beautiful
person — who just
happens to be a
woman.

I live by being
myself,
not by defining
myself.
I have characteristics
not labels.
I have passions,
hopes, flaws, ideas
desires, and dreams.

So really... what's
all the fuss
thinking I'm
 different?

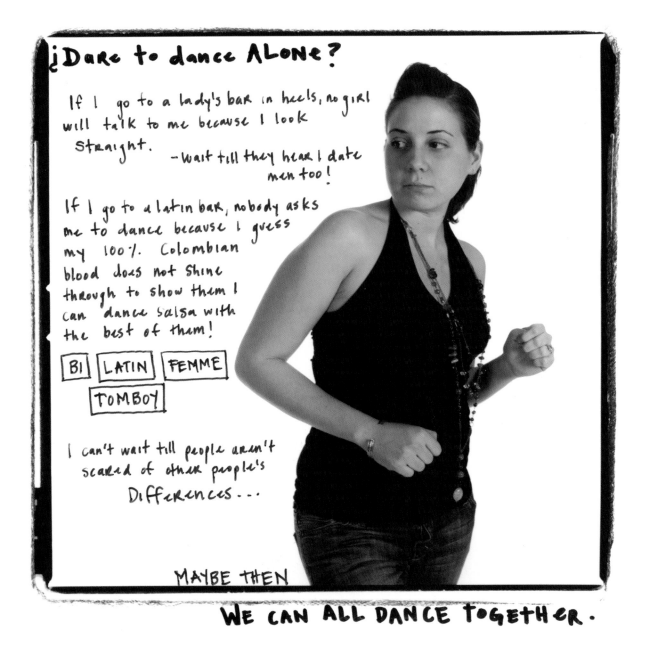

¿Dare to dance ALONe?

If I go to a lady's bar in heels, no girl will talk to me because I look straight.
— Wait till they hear I date men too!

If I go to a latin bar, nobody asks me to dance because I guess my 100% Colombian blood does not shine through to show them I can dance salsa with the best of them!

BI LATIN FEMME TOMBOY

I can't wait till people aren't scared of other people's Differences...

MAYBE THEN

WE CAN ALL DANCE TOGETHer.

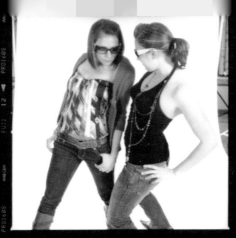

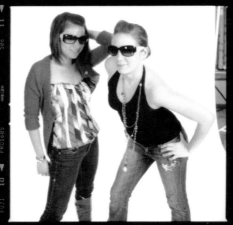

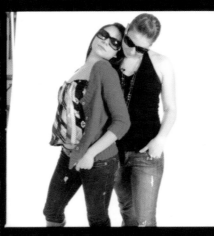

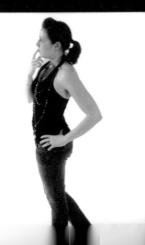
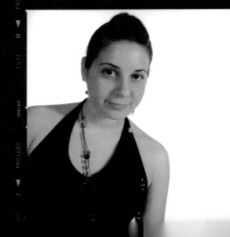

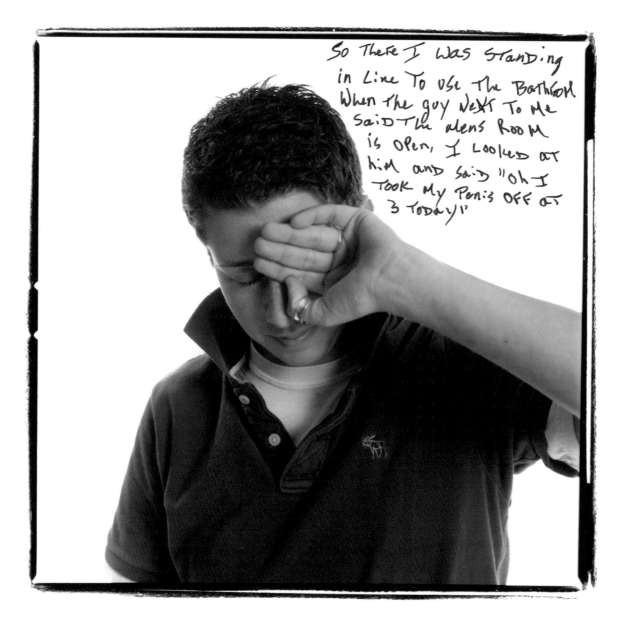

DANCE THE LIFE FANTASTIC...

I feel like the luckiest person
alive.
Yes I've endured my fair
share of
gaybashing,
questions about my gender,
and ridicule;
I see it all meaning so very little
in the big scheeese of my life,
for my amazing family and friends give me
the strength I possess to move forward.

FOR YOU ONLY HAVE ONE LIFE TO LIVE.

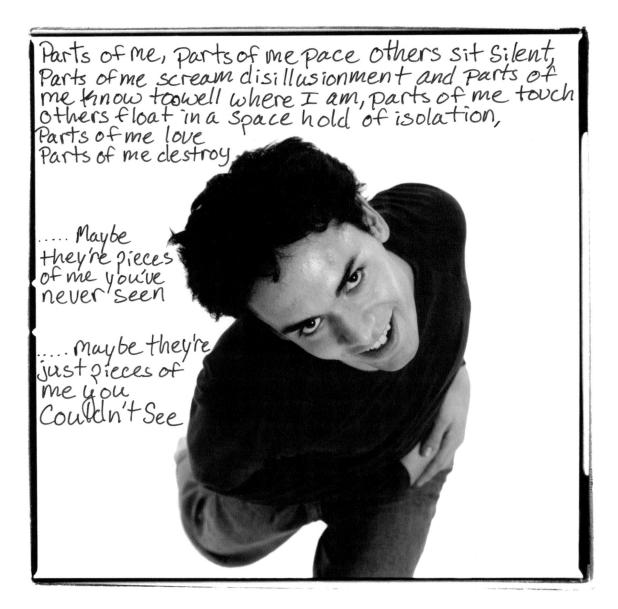

Parts of me, Parts of me pace others sit silent,
Parts of me scream disillusionment and Parts of
me know too well where I am, parts of me touch
others float in a space hold of isolation,
Parts of me love
Parts of me destroy

..... Maybe
they're pieces
of me you've
never seen

..... maybe they're
just pieces of
me you
couldn't see

86

JOHN ➡ ELEVEN YEARS LATER

I have been dancing professionally for the past eleven years. I am a choreographer and an intuitive healer now. I look back on my picture and what I wrote and remember how angry and wild I was. Because of what I had experienced in my life growing up with people who didn't understand me. Now I am using what I have experienced to understand people and where they come from instead of hating them for hating me.

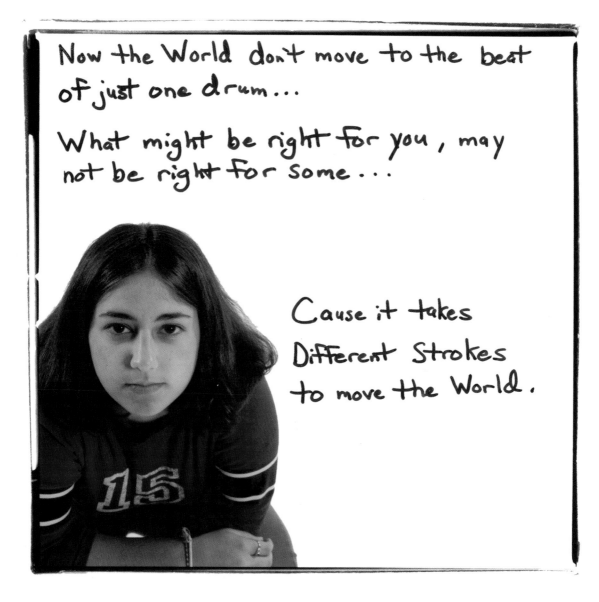

Now the World don't move to the beat of just one drum...

What might be right for you, may not be right for some...

Cause it takes Different Strokes to move the World.

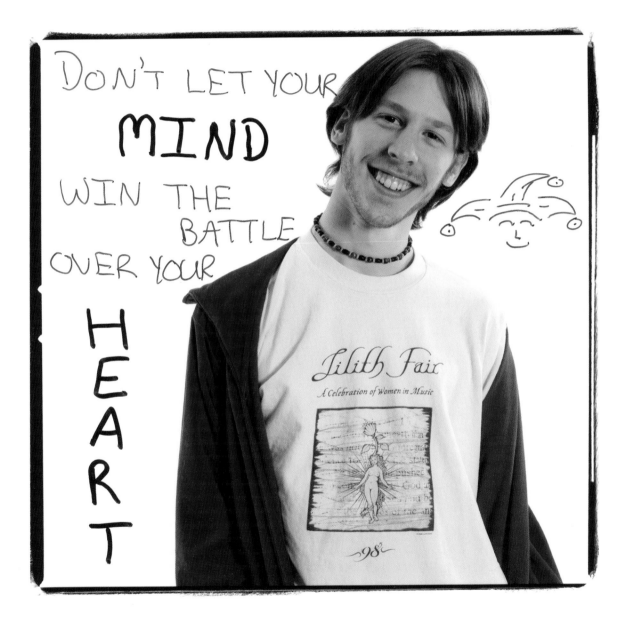

"Rachelle Lee Smith's photographic project presents us with the face and the voice of this generation of LGBT youth: they are passionate, angry, funny, and committed. This project is critical not only for young queer people, but for their teachers, parents, mentors, and friends."

Sean Buffington
President,
The University of the Arts

ATANASIO 7/24/04

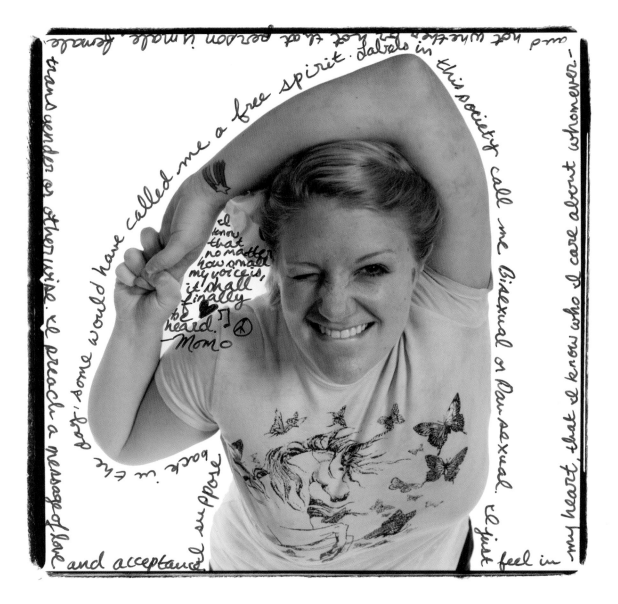

They have called me a free spirit. Labels in this society call me Bisexual or Pansexual. I just feel in my heart, that I know who I care about whomever — and not whether they be that person is male female transgender or otherwise. I preach a message of love and acceptance support back it the day. I only spread some.

[I know that no matter how small my voice is, it shall finally ♥ to be heard.] ☮ ①
—MOMO

Coming out has been a pretty positive experience for me. It's helped me to evolve into the person that I am today, and be happy about it; since my sexuality is such an integral sense of myself. Being open about my sexuality has allowed me the freedom to express my love for and attraction to women- their sensuality, their emotions, and their bodies and minds. It has allowed me to be uninhibited in being the person I am, and not be offended or surprised when people recheck the sign on the lady's room door because they see a woman with a shaved head.

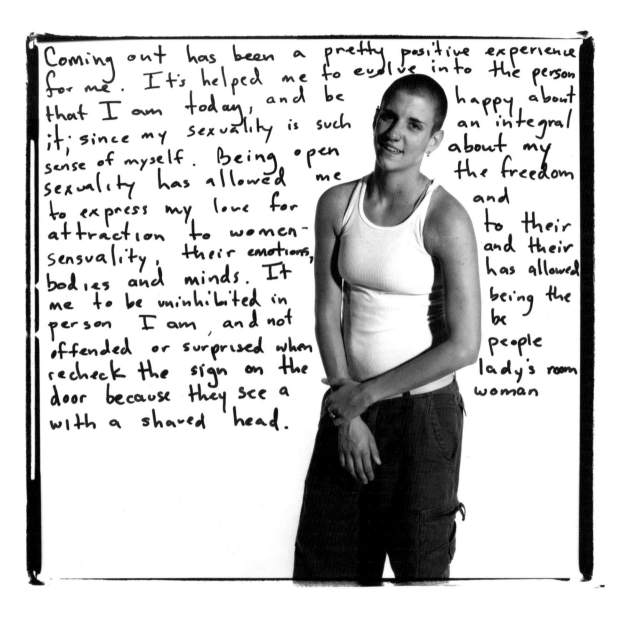

PEOPLE HAVE OFTEN QUESTIONED
MY CHOICE OF PROFESSIONS
BECAUSE OF MY SEXUALITY.
I AM A LESBIAN AND A
FIRST GRADE TEACHER.
THIS COMBINATION, TO ME,
IS A UNIQUE OPPORTUNITY
TO MOLD THE MINDS
OF TOMORROW — TO
GIVE THEM THE
TOOLS, NOT TO
JUDGE, BUT TO
ACCEPT AND
EMBRACE HUMAN
DIFFERENCES
AND TO CHERISH
THESE
DIFFERENCES AS
THE CORE OF THE
HUMAN
EXPERIENCE.

JESSICA

My how my life has changed in the last 7 years! I am incredibly, happily married and trying to start a family. I am a mentor educator with 6 years under my belt. I am happier than I have ever been. I live a complete life, with an amazing support network and the most incredible person to share my life with. When I look back at my photo I think about how incredibly young I look and how my words seem so grown-up. When I look back I was such a new and idealistic educator as opposed to who I am now. It is almost that I was so proud or so connected to my career that it was who I was as opposed to what I do. That being said, I am a far better educator now but I know the difference between my life and my job, and while I love the fact that I shape young minds in an open-minded way it is probably not what I would've written about. Being a teacher is probably where I focused because my transition to being identified as gay/lesbian was fairly easy. I know my parents gave me a bit of a hard time, but honestly I was blessed with never having faced true discrimination (at least to my face). I think if I could rewrite it today, I would've said,

"Realizing I was attracted to women was a gift to me.

It gave me a life that made more sense to me.

It has provided me with a truer love than I had ever imagined possible.

And though there are people who may make your life harder,

the love far outweighs anything else.

And for this I am eternally thankful."

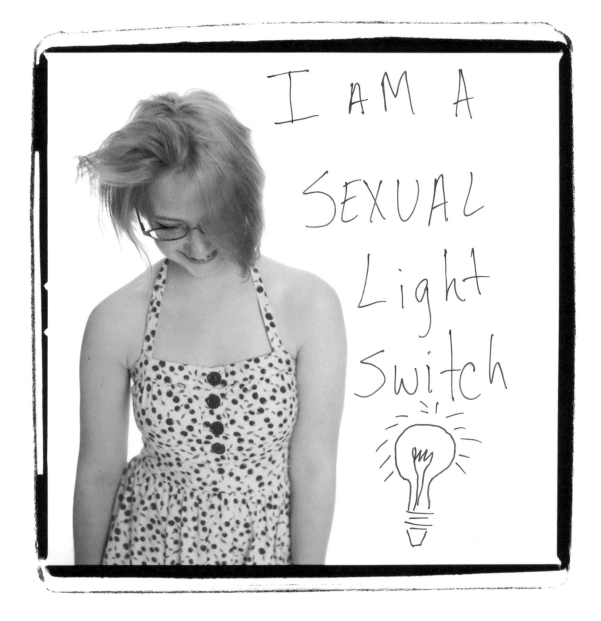

I AM A SEXUAL Light Switch

Felonious

Unlawful

Carnel

Knowledge

He believes in beauty
He's Venus as a boy
—Bjork

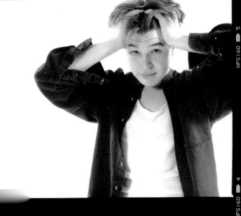
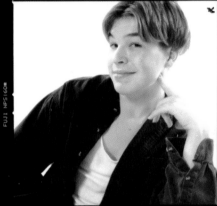

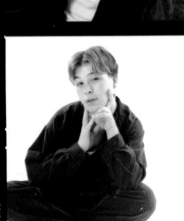
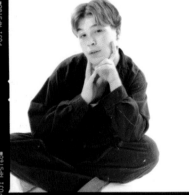
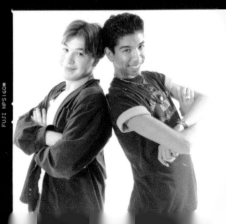

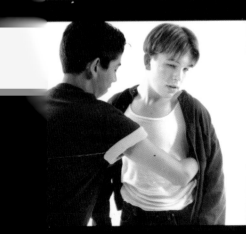
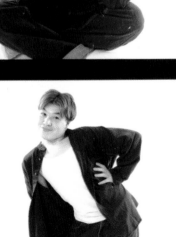

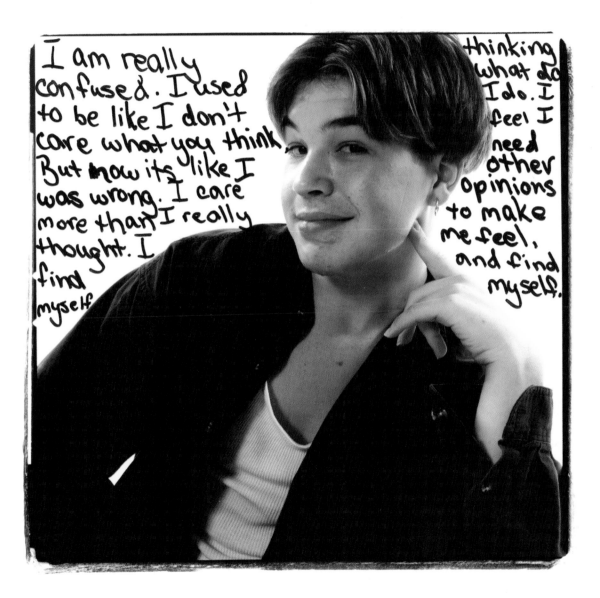

I am really confused. I used to be like I don't care what you think. But now its like I was wrong. I care more than I really thought. I find myself

thinking what do I do. I feel I need other opinions to make me feel, and find myself.

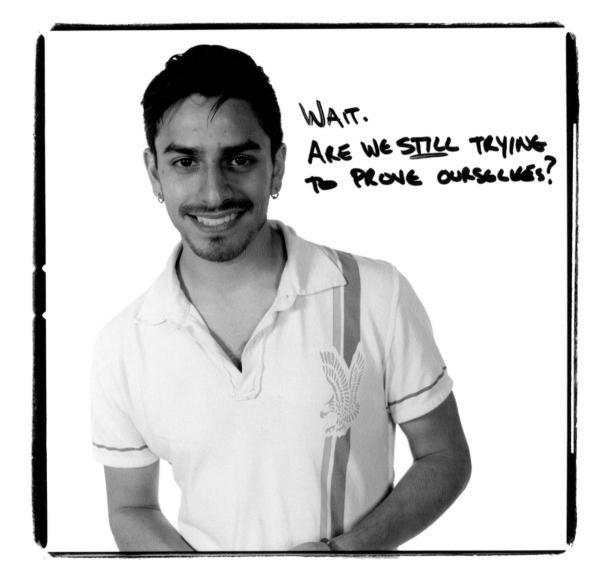

FOR THE RECORD, I DON'T TRY TO PASS. IT JUST HAPPENS. ...so get off my back. THAAAANKS.

Lee Smith

Welcome to the
Media Arts Department
Photography/Film/Animation/Digital Video

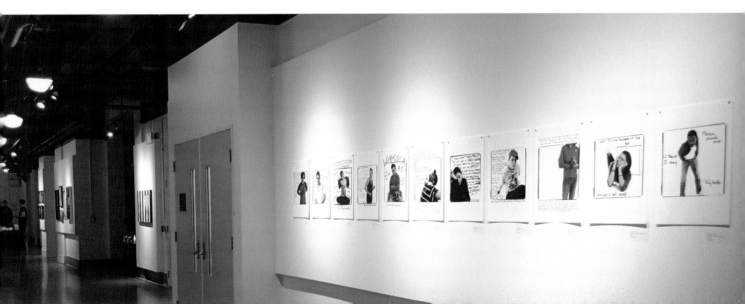

First you will notice my...
And the way I walk.
Then if you look a
little closer, you
may see the
clothes I wear.
And the keys
hanging from
my belt. You
may even
correctly guess
that I'm a
LESBIAN.
But... don't assume
that tells you everything
about ME!

HAIR

TIFFANY

When I first participated in the project, I barely made the age cutoff. But I truly believed in the project and felt that I still had a voice as a youth that needed to be heard. I am now 30. The most significant change is that the blond hair is gone, but the afro remains. People still remember that crazy blond hair that I sported, and it still remains a topic of conversation for those who knew me at that time. At the time of the photo I was working in the sexual health field, helping youth make healthier decisions about sex. Now, I remain in that field, but I focus more on homeless youth at an organization called the Youth Health Empowerment Project as their communication and operations supervisor. I am only a couple of months away from getting my masters in communication from Temple University. I have been very lucky in my life and career as a butch-identified lesbian with a masculine gender presentation, but I have to give some credit to feeling confident in my own skin. The time that photo was taken, I was still trying to find myself and had a lot of unanswered questions about how I could fit in this world when I wasn't engulfed by the comfort of the queer community. When I read what I wrote, I sometimes think that I could have said so much more about who I was as a person but my hair was such a visible piece of my identity. I do not feel that I would change a word of what I wrote. It was who I was at the time and part of my character building. This photo reminds me of a time when I was young and ready to take over the world, and that is a feeling that I hope to not lose as I grow older. If I was to write on that photo now, I would write that "the freedom and courage to live up to the identity that is most comfortable for you, despite what society may think of you, is the biggest gift you can give yourself. As I walk through this world being completely true to myself, both inside and outside, I can fear nothing, because nothing can break me if I feel that I am as strong as I need to be." I am prouder now of being a lesbian than I was back then, and more importantly a black butch-identified lesbian. My openness will hopefully inspire the next young person I come across to live up to whatever they desire to be in life.

"The power of a look, a pose, and a story can be seen through Rachelle Lee Smith's photography and the youth who opened up their raw emotions, insecurities, and celebrations to us all. Sharing stories saves lives, but also reminds us that there can be continual struggle in finding identity and acceptance."

Ryan Sallans
Transgender speaker and author of
Second Son: Transitioning Toward My Destiny, Love and Life

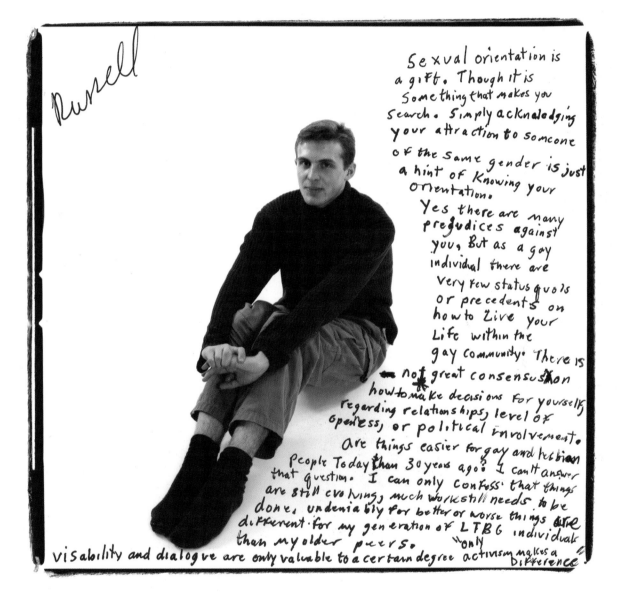

Russell

Sexual orientation is
a gift. Though it is
something that makes you
search. Simply acknoledging
your attraction to someone
of the same gender is just
a hint of knowing your
orientation.
 Yes there are many
prejudices against
you, But as a gay
individual there are
very few status quods
or precedents on
how to live your
life within the
gay community. There is
not great consensus on
how to make decisions for yourself,
regarding relationships, level of
openess, or political involvement.
 Are things easier for gay and lesbian
people Today than 30 years ago? I can't answer
that question. I can only confess that things
are still evolving, much work still needs to be
done. undeniably for better or worse things are
different for my generation of LTBG individuals
than my older peers. "Only activism makes a
visability and dialogue are only valuable to a certain degree difference"

Living, Learning, and Loving ME.
Destruction has fallen upon ME,
As a Cat destroys and devours a mouse,
As an explosion destroys a building

People will gather around to watch it flop
That same building can be rebuilt, those
same people can watch it be remounted

I can be rebuilt.
I can be remounted.

To grow,
To be new,
To be Me.

Challenges have obscured my vision.
A vision so clear now by the shouts of rain
from above washing away the dirt clean.
Living, Learning, and Loving Me.
Will forever be my empowerment,
And above will forever be my strength.

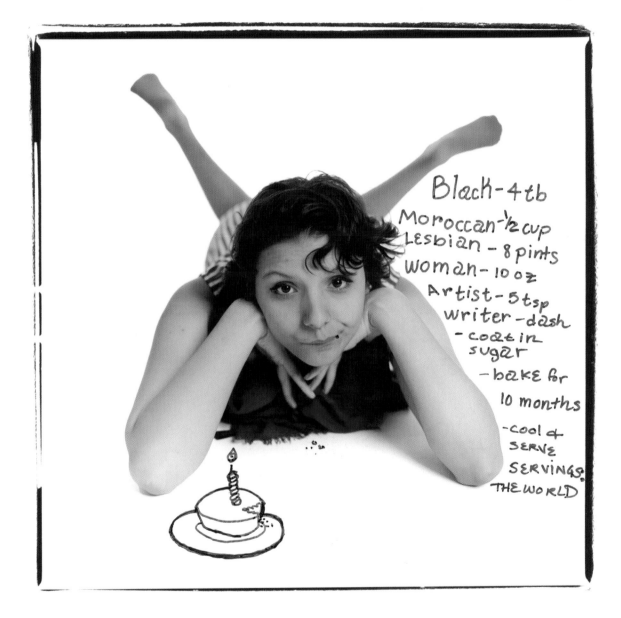

Black - 4 tb
Moroccan - ½ cup
Lesbian - 8 pints
Woman - 10 oz
Artist - 5 tsp
writer - dash
- coat in
sugar
- bake for
10 months
- cool &
serve
SERVINGS:
THE WORLD

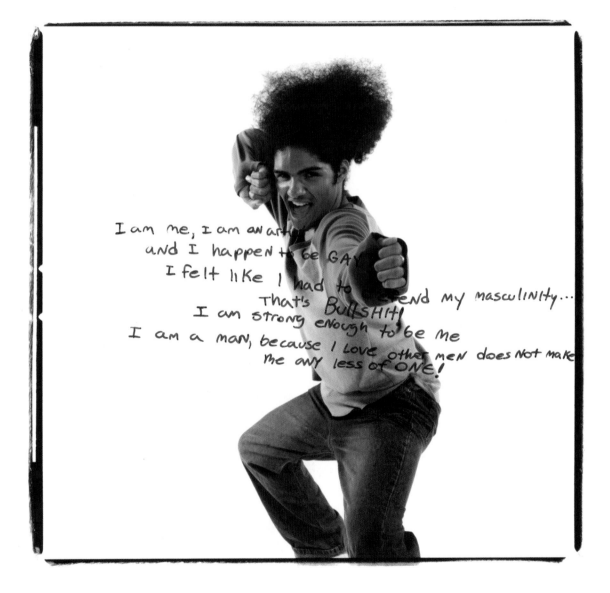

"These stories, experiences, and activism have great potential to bring us to a future where people across gender and sexuality spectrums will live freely, unencumbered by social taboos and cultural norms of gender and sexuality."

Warren J. Blumenfeld, Ed.D.
Professor, University of Massachusetts, Amherst

The Attic Youth Center Gay Pride

To be Gay is to be Free. To be yourself and not be Afraid to be who you are.

If someone puts you down because you are Gay just remember to hold your head up high And strive for

"Success!"..

"United we All Stand" Treat others with Love and Respect

"Love is Peace, knowledge is Power, and Respect is Understanding". God bless America, Sisqo!!

Coming out was easy - it was learning to live with being gay that was the hard part. I've been out for almost 10 Years and every day seems to get more and more difficult. I've been labeled, discriminated against and punched by a bar owner that didn't want a DYKE in his bar. I feel uncomfortable when I meet new people and they ask me if I have a boyfriend. Will they understand?

Does AnyOne Understand?

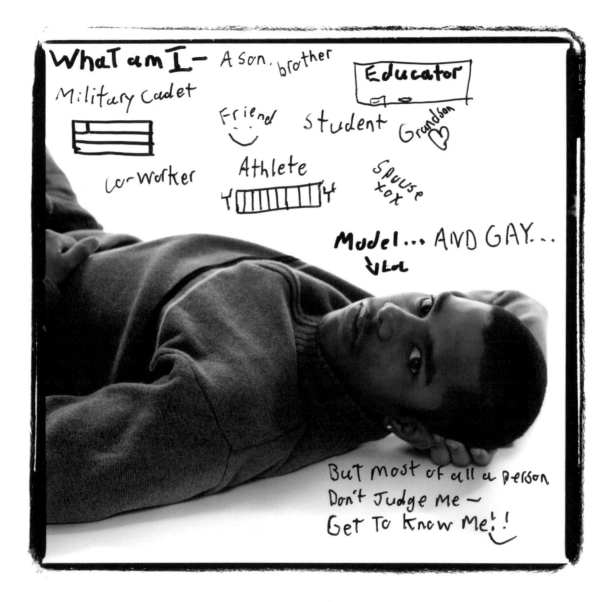

The strength within me to stay true to who I am is a virtue I will always Praise.

Daughter.

Photographer.

Singer.

Friend.

Lover.

Lesbian.

Artist.

Woman.

advocate.

I am Proud to be Me.

FOR YOU, SOMEONE YOU KNOW, OR SOMEONE WHO NEVER HAD THE CHANCE TO BE REPRESENTED.

Graeme Taylor

What were the odds?

Really, what were the odds that seven months after a fourteen-year-old boy came out, he would have met and gotten to know three gay rights game-changers: Ellen DeGeneres, Cleve Jones, and Kevin Jennings?

In October of 2010, when I was a high school freshman in Ann Arbor, Michigan, I made a little speech at a school board meeting. The speech made the news, went viral, and the next thing you know, I was guesting on *The Ellen DeGeneres Show*. On her show, Ellen was curious about how friends reacted when I came out and she seemed a little in awe of my answer. My experience was not her experience.

Ellen could not have been kinder to me, and when you appear on her show, doors open. One of those doors led me to Cleve Jones. You know, the guy who worked on Harvey Milk's staff; the guy who conceived the idea of the AIDS Memorial Quilt. Today, Cleve is both an activist and a walking history book. In April of 2011, while in San Francisco to give a speech, I was invited to a dinner that Cleve attended. How real was it to sit next to Cleve and listen to him tell the inside story of the 1979 White Night riots? Very.

Another door led me to Kevin Jennings, you know, the guy who founded what is now called GLSEN, the Gay, Lesbian & Straight Education Network. Kevin was serving as the assistant deputy secretary for the Office of Safe and Drug-Free Schools in June of 2011. That's when he invited me to the Department of Education's LGBT Youth Summit, held in Washington, DC. At the closing session of the

AFTERWORD

conference, I will never forget Kevin's heartbreaking story of feeling utterly alone growing up as a gay youth.

Really, that's what all three of these charismatic leaders had in common, stories about feeling alone when they were growing up. Alone simply because they were gay. For me, big difference. When I came out in person with my closest friends and on Facebook with everyone else, the response was 100 percent supportive—100 percent!

But that support, I quickly learned, was not the result of good karma. It was the result of the blood, sweat, and tears shed by those who came before me. The Ellens, the Cleves, the Kevins of the world, and countless others, used their intelligences and talents and courage to help create the soft landing I made after I said those two little words, "I'm gay."

Good for me, right?

Ah, but I understand that the history book has not yet been closed. While we have taken giant strides toward equality, yes, there is more work to be done.

While we have taken giant strides toward equality, yes, there is more work to be done.

Enter: Rachelle Lee Smith.

I met Rachelle while heading to my first session at that LGBT Youth Summit held at the Washington Court Hotel. There she stood, smiling brightly behind a table just outside the conference room—cool bangs, hair pulled back in a little

ponytail. Spread out on the table were prototype copies of her book, *Speaking OUT: Queer Youth in Focus*. More cool. On several nearby easels, Rachelle displayed enlarged pages from the book. I studied her distinctive portraits with the infinity-white backgrounds. I was curious about the handwritten text on the photographs. It didn't take long to figure out the subjects had been given the freedom to write whatever they wanted. Cool that, too.

Hmmm, what would I write if I were in Rachelle's book?

We talked; it was casual. Kind of like old friends who hadn't seen each other in a while. I liked Rachelle from moment one and wanted her to like me too.

We were to meet again. The following summer I returned to Washington, DC, for three exciting reasons. First was the privilege of winning an award at the National Education Association's Human and Civil Rights Dinner. That's when I got to sit at the same table as Juanita Abernathy, the wife of Ralph David Abernathy Sr. Two months earlier, I had studied the life and work of Dr. Abernathy in my history class, and he was my hero! Second, I also had the privilege of being the keynote speaker at the NEA GLBT Caucus Robert Birle Memorial Dinner. Big room, big smiles. Third, on July 4, 2012, I got to pose for Rachelle's book!

Humans cannot live forever and the changing of opinions in one generation leads to the changing policies of another.

Rachelle drove down from Philadelphia with tons of cameras and photography equipment. It was a blazing hot day, but for my session, we found a cool spot in my hotel's downstairs lobby. Rachelle was so much fun to work with. She's smart and cool and very sweet. And what a photographer! When finished, she asked which photograph I liked best. Impossible question—she made me look good in all of them.

When I finally made my choice, she said, "I am going to print it and then I want you to write something." So, she printed my photograph and then handed me a Sharpie

and said, "Write whatever you want. I'll wait here." I walked over and quickly jotted down, "Sorry, we won." (And then I went swimming in the hotel pool.)

"Sorry, we won" because I feel the decision is written. Humans cannot live forever and the changing of opinions in one generation leads to the changing policies of another. Young Westerners are clearly supportive of LGBT rights, and those who aren't are becoming rare. If the rate of support among young people persists, by the time we become the majority voting bloc we'll most likely see the generations below us also voting in favor, similar to how acceptance of black civil rights has "trickled down" to near 100 percent for white teens today.

But who is "we"? How do you zoom in on those individuals within the "we"? The great crime of any movement is that thousands upon thousands of individuals who work just as hard as anyone else are overlooked. How do these people get a voice?

The great crime of any movement is that thousands upon thousands of individuals who work just as hard as anyone else are overlooked.

Rachelle.

She is the mouthpiece for our story. I cannot think of a better way to document an individual's experience than the way Rachelle does it. Capturing us in the moment, showing our present selves frozen in time, accompanied by our opinions of the time, gives an image and voice to those who might otherwise be forgotten. And by giving us a voice, we are permitted to teach and inspire other individuals with real-life stories of young people who choose to reveal their true selves to anyone who cared to look.

Speaking OUT: Queer Youth in Focus: a beautiful chapter in that history book that has not yet been closed. From my heart, thank you, Rachelle Lee Smith.

Graeme Taylor
Ann Arbor, Michigan, May 2014

Contributors & Respected Resources

arcus FOUNDATION

arcusfoundation.org

the attic youth center

atticyouthcenter.org

HAWKINS LifeWorks LLC

Linda A. Hawkins, PhD, MSEd, LPC

hawkinslifeworks.com

PHILADELPHIA FIGHT / y-hep

Philadelphia FIGHT / Youth Health Empowerment Project

fight.org / y-hep.org

SAMSPHILLYMIXER.COM

samsphillymixer.com

Philly AiDS Thrift SINCE 2005 SHOP • DONATE • VOLUNTEER

phillyaidsthrift.com

First Presbyterian Church PALO ALTO

fprespa.org/

QUEERTY

FREE OF AN AGENDA. EXCEPT THAT GAY ONE.

queerty.com

Campus Pride

www.CampusPride.org

campuspride.org

THE TREVOR PROJECT

saving young lives

thetrevorproject.org

For motivation, constant love, and support, an extra special THANKS

Megan, my love

Smith and Wolfe families

Schneider and Closson families

Christina Beck

Alyssa Hargrove—assistance and persistence

Kim Bunce—videography

Elyssa Cohen—web design

Edith Clee and Elana Caplan—consulting

The University of the Arts and the UArts Photography Department

The fabulous folks at PM Press and Reach & Teach

Kevin Jennings

Every person in this book and those who still have a story inside

THANK you {

I'd like to thank the following people for their generous support and contribution Beth Ahavah and Rodeph Shalom • Robin L. Allen • Tammy L. Anderson • Kelsie Baab • The Bailey Family • Dana Bunce • Kim Bunce • Edith Clee and Emily Choromanski • Carmella Cocchiola • Dragonette • Equality Forum • The Fillmyers • Heather Goldberg • Michele Gudknecht • Valerie Herbe • Jessica Howe • Carrie Jacobs • Patrick Jones • Michael Knight • Ladies 2000 • Malcolm Lazin • Jessica Howe Lowing • Jen Martin • Molly McGovern • Mandy Messinger • Ken Miraski Sr. • Allison Muchorski • Doris and Walter Muchorski • Jo Ellen Muchorski • Rowena Wolfe-Paupst • Puppet • Elizabeth Profy • B. Proud • Hope Rovelto • Megan Schneider • Richard and Susan Schneider • Victoria Skowronski • Edward and Marcia Smith • Hilary Spears • David Timmons • Nicola Visaggio • Jay Walker • Hattie Wilcox • The William Way Community Center

"Rachelle's work speaks volumes— telling stories that need be told and giving voice to those whose lives need to be heard. She has created an opportunity for LGBTQ youth to express their power and voice. I believe that every young person who witnesses this work will feel a part of that power."

Carrie Jacobs, PhD
Executive director,
Attic Youth Center (PA)

Rachelle Lee Smith is a Philadelphia-based, award-winning, nationally and internationally shown and published photographer. Rachelle's work in *Speaking OUT: Queer Youth in Focus* combines her passions for activism and photography to tell the stories of, and provide a rare insight into, the evolving passions, confusions, prejudices, fulfillment, joys, and sorrows of queer youth.

Candace Gingrich is the Youth & Campus Engagement associate director at the Human Rights Campaign in Washington, DC. Her involvement in the movement for queer equality began when her brother, Rep. Newt Gingrich, R-GA, was elected House speaker.

Graeme Taylor skyrocketed to international attention at age fourteen when he confronted a school board for not defending gay rights in its schools. In the process, he became one of the youngest and most widely known openly gay teens in America. He was interviewed on MSNBC's *Jansing & Co.* and *The Ellen Degeneres Show* and is now the subject of a short film, *Shrug*.

Friends of PM Press

These are indisputably momentous times—the financial system is melting down globally and the Empire is stumbling. Now more than ever there is a vital need for radical ideas.

In the seven years since its founding—and on a mere shoestring—PM Press has risen to the formidable challenge of publishing and distributing knowledge and entertainment for the struggles ahead. With over 250 releases to date, we have published an impressive and stimulating array of literature, art, music, politics, and culture. Using every available medium, we've succeeded in connecting those hungry for ideas and information to those putting them into practice.

Friends of PM allows you to directly help impact, amplify, and revitalize the discourse and actions of radical writers, filmmakers, and artists. It provides us with a stable foundation from which we can build upon our early successes and provides a much-needed subsidy for the materials that can't necessarily pay their own way. You can help make that happen—and receive every new title automatically delivered to your door once a month—by joining as a Friend of PM Press. And, we'll throw in a free T-shirt when you sign up.

Here are your options:

- **$30 a month:** Get all books and pamphlets plus 50% discount on all webstore purchases
- **$40 a month:** Get all PM Press releases (including CDs and DVDs) plus 50% discount on all webstore purchases
- **$100 a month:** Superstar—Everything plus PM merchandise, free downloads, and 50% discount on all webstore purchases

For those who can't afford $30 or more a month, we have introduced Sustainer Rates at $15, $10, and $5. Sustainers get a free PM Press T-shirt and a 50% discount on all purchases from our website.

Your Visa or Mastercard will be billed once a month, until you tell us to stop. Or until our efforts succeed in bringing the revolution around. Or the financial meltdown of Capital makes plastic redundant. Whichever comes first.

Girls Are Not Chicks
Coloring Book

Jacinta Bunnell and Julie Novak
$10.00 • 8.5x11 • 36 pages

Twenty-seven pages of feminist fun! This is a coloring book you will never outgrow. *Girls Are Not Chicks* is a subversive and playful way to examine how pervasive gender stereotypes are in every aspect of our lives. This book helps to deconstruct the homogeneity of gender expression in children's media by showing diverse pictures that reinforce positive gender roles for girls.

"Get this cool feminist coloring book even if you don't have a kid."
—Jane Pratt, *Jane* magazine

Sometimes the Spoon Runs Away with Another Spoon
Coloring Book

Jacinta Bunnell • Illustrated by Nathaniel Kusinitz
$10.00 • 8.5x11 • 36 pages

We have the power to change fairy tales and nursery rhymes so that these stories are more realistic. In *Sometimes the Spoon Runs Away with Another Spoon* you will find anecdotes of real kids' lives and true-to-life fairy tale characters. This book pushes us beyond rigid gender expectations while we color fantastic beasts who like pretty jewelry and princesses who build rocket ships. Celebrate sensitive boys, tough girls, and others who do not fit into a disempowering gender categorization.

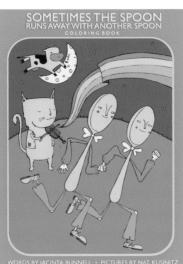